IMAGES
of America

SAYREVILLE

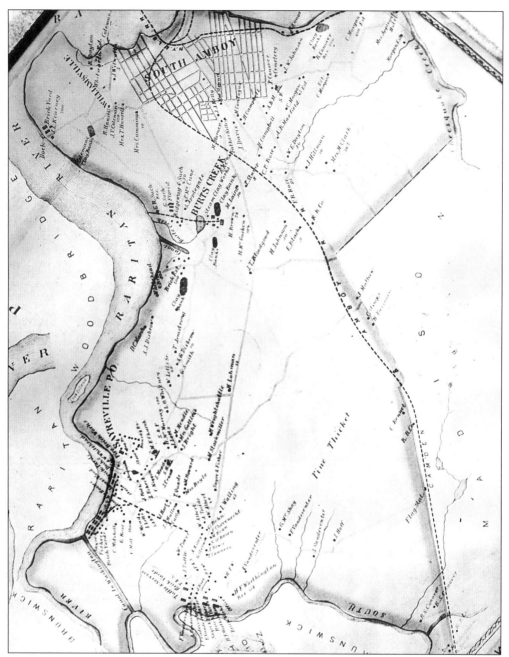

Once a portion of the south ward of Amboy, Sayreville separated from South Amboy and, on April 5, 1876, was officially founded as the Township of Sayreville. The township is shown *c.* 1878. Native American tribes were living in the area in 1656, and King George of England began offering land grants along the Raritan River in 1760. Settlement began *c.* 1770. Sayreville was a small village that grew under the influence of an extensive brick and clay industry.

IMAGES
of America

SAYREVILLE

Sayreville Historical Society

ARCADIA

First printed in 2001.

Published by Arcadia Publishing,
an imprint of Tempus Publishing, Inc.
2A Cumberland Street
Charleston, SC 29401

Printed in Great Britain.

Library of Congress Catalog Card Number: 00-106517

For all general information contact Arcadia Publishing at:
Telephone 843-853-2070
Fax 843-853-0044
E-Mail sales@arcadiapublishing.com

For customer service and orders:
Toll-Free 1-888-313-2665

Visit us on the internet at http://www.arcadiapublishing.com

*We respectfully dedicate these memories to
all those who ever called Sayreville home.*

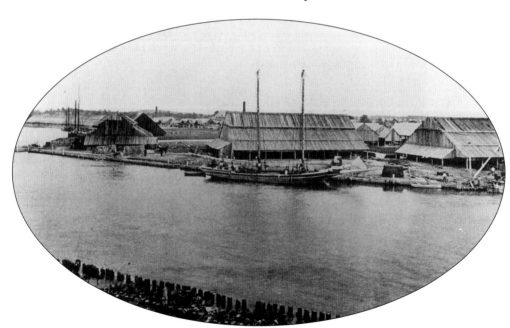

This view of the brick sheds at the common yards of the Sayre & Fisher Company brick works dates from 1880.

CONTENTS

ACKNOWLEDGMENTS

Our grateful appreciation goes to those residents, current and former, who have so generously shared with us their personal and family memories and albums. Special thanks is due to members and friends of the Sayreville Historical Society for their support as we compiled photographs and history for this publication.

—The Book Committee of the Sayreville Historical Society:
Helen Boehm, chair; Florence M. Roginski, editorial chair;
Irene L. Jorgensen, assistant; Alfred J. Baumann, Florence B. Cooney,
Edward C. Engelhardt, Frank Hendershot, Edwin A. Kolodziej,
Robert C. Puchala, and Edward S. Pytel.

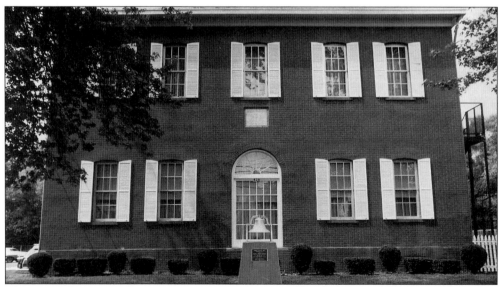

The Sayreville Historical Society, founded in 1974, is dedicated to "preserving the past to serve the future," as its motto reads. In 1984, New School No. 1 (built in 1885) became the permanent home of the Sayreville Historical Society Museum.

INTRODUCTION

Incorporated in 1876, Sayreville is situated in central New Jersey on 16 square miles of land along the southern bank of the Raritan River. The first recorded evidence that Native American family groups inhabited the area dates from 1656. Absentee owners purchased land around the South and Raritan Rivers as early as 1683. Settlement began *c.* 1770 but was slow because the sandy soil was not well suited to agriculture. The site soon became known as Roundabout by watermen navigating the Raritan because of the river's U-shaped bend at that point. The area was sparsely populated until the mid-1800s, when the clay and brick industries brought in waves of laboring immigrants to meet the immense demand for their materials and products, introducing growth and prosperity to Sayreville. Traditionally an industrial town, it has been transformed into a thriving residential community of 40,000 people.

Of special note in the town's history are the first rail line in the state and the second major railroad in America (the Camden & Amboy Railroad), the earliest stoneware works (the Price and Morgan Potteries), and a prominent role in a fledgling motion picture industry (the films *Juggernaut* and *The Perils of Pauline*). It has been home to nationally known industries: E.I. duPont de Nemours, International Powder & Chemical Company, Hercules, Atlas Powder, T.A. Gillespie Shell Loading Company, the National Lead Company, and the world's largest brick-manufacturing center—the Sayre & Fisher Company.

The purpose of this book of historical images is to celebrate and preserve the rich heritage of Sayreville. We hope you will enjoy this journey into a bygone era as much as we have enjoyed writing it for you.

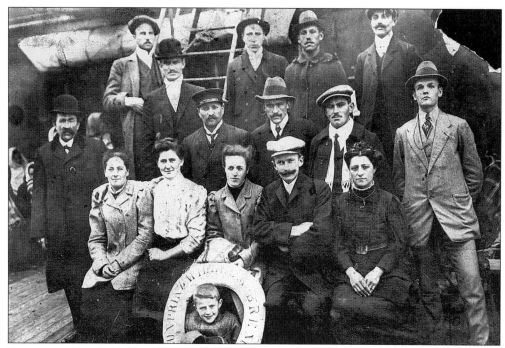

Passengers aboard the *Krun Prinz Wilhelm* of Bremen, Germany, were bound for the United States and the promise of new and greater opportunities. Among the arrivals in this 1911 photograph is Julie Weck (age 25), seated third from the left.

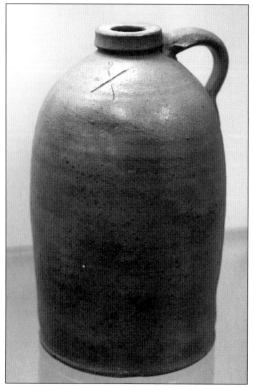

This one-gallon, salt-glazed *c.* 1830 jug bears the incised X on the shoulder. The jug is ascribed to Xerxes Price of Price Pottery.

One

BRICK BY BRICK
A TOWN WAS BUILT

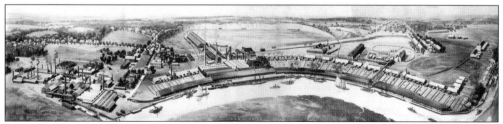

The Sayre & Fisher Company was a mainstay of Sayreville's economy in the late 19th and early 20th centuries, a place where generations of families found employment. The company manufactured building brick that was used in the construction of prominent sites—including the Empire State Building, Rockefeller Center, and the base of the Statue of Liberty—as well as many of Sayreville's homes, churches, schools, and municipal buildings. This panoramic view dates from c. 1880.

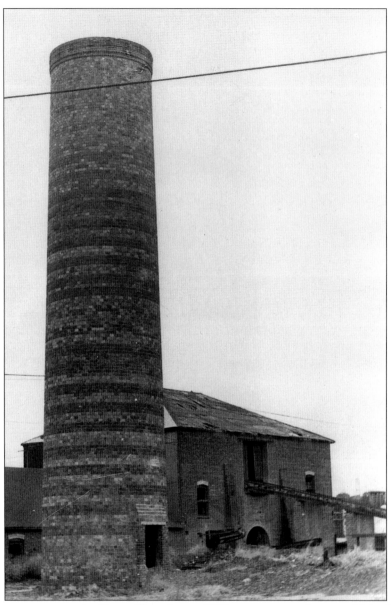

The signature structure in Sayreville—the c. 1875 water tower base on Main Street and Memorial Way—is all that remains of the Sayre & Fisher Company. A wooden tank atop the tower was the source of water used to soften clay so it could be easily pressed into brick. James Sayre originally chose the Roundabout section of South Amboy as the company's location. When the area separated from South Amboy in 1876, it was given the name of Sayreville. The Fishers' long association with the company spanned three generations: Edwin followed his father as general manager and, in 1908, succeeded James Sayre as president; Edwin's son Douglas J. was named president in 1927. Douglas Fisher resigned in 1932 when the family divested all of its company interests. The general decline of the brick business led to the permanent closing of the company in 1970 and demolishing of the plant in the early 1970s. A brass plaque on the restored 40-foot tower dedicates the site as a memorial to those immigrants who by "their toil, labors, and work ethics, built a solid foundation for the community."

In 1850, James R. Sayre of Newark and Peter Fisher formed a partnership for the manufacture of brick along the Raritan and South Rivers. Sayre, an entrepreneur engaged in the lime, cement, and building supply businesses, provided the venture capital. The company incorporated in 1887 as the Sayre & Fisher Company with Sayre as president. He continued in that capacity until his death in 1908.

Capt. Peter Fisher from Fishkill, New York, owned and operated a sailing vessel that freighted both brick and other products in and around New York Harbor. He became cofounder, copartner, vice president, and general manager of the Sayre & Fisher Company and was responsible for the operation of the plant from its founding until 1906. Fisher brought both practical experience and operating technology to the partnership.

11

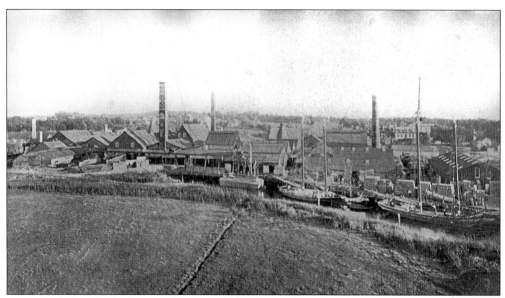

This north view of the Sayre & Fisher enamel and fire brick works dates from *c*. 1880. The first brick manufacturer in Sayreville was the Wood Brick Works, which was in business between 1840 and 1850. Sayre & Fisher bought that company when it began to falter in 1850. By 1905, the Sayre & Fisher plant spanned almost two miles along the Raritan River and included 13 individual brickyards. This photograph was first published in 1896 in *Art Work of Middlesex County, New Jersey*.

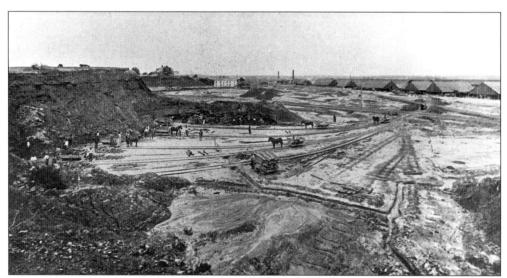

Clay was dug by hand from open pits, loaded into one-horse dump carts, and taken to tempering pits. This method was followed until 1894, when the horses and carts gave way to narrow-gauge tracks and cars. Mules were still used to pull the cars until 1896, when the company purchased several locomotives. Shown here are the east clay banks at the common brickyards.

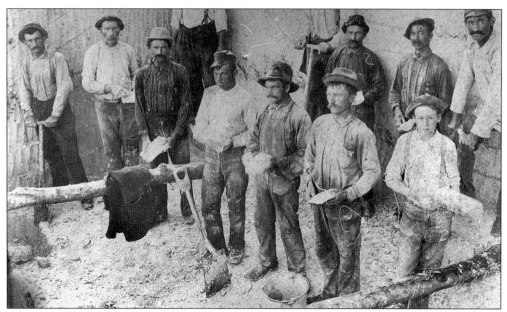

Sayre & Fisher workers pause in their labors for this *c.* 1880 photograph. There were no child labor laws, and boys as young as seven were assigned work in the yards. Women also toiled in the yards but for a lower wage than that of their husbands. Employees received their wages twice a year, and the earnings of women and children were paid to the head of the household. In 1920, workmen received a wage of $4 a day.

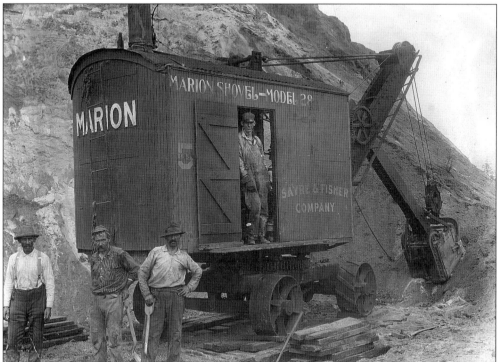

Until 1895, clay was dug out of open pits by hand shovels. In that year, the first steam shovels were put into operation.

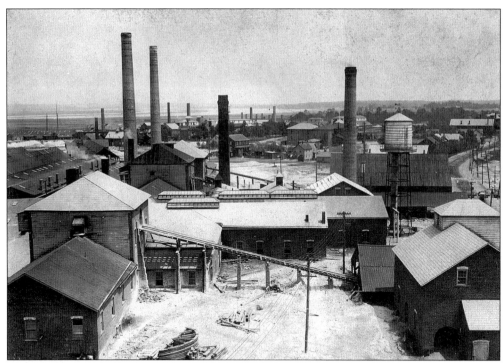

This photograph shows the Sayre & Fisher plant layout *c.* 1890. Freshly mined clay was hauled up the pitched ramp to the mixing room. It was then moved to press rooms to be formed and piled on pallets for transfer to drying fields or sheds. After drying for between 10 and 30 days, the green bricks were moved to huge kilns to be fired, turning them into red bricks in the last step before shipping.

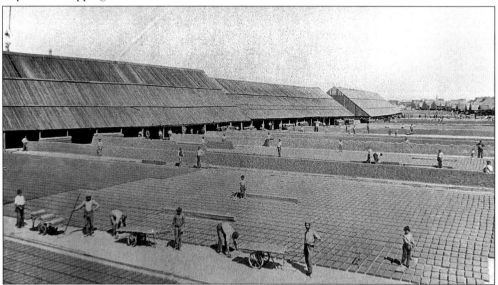

In early years, red building brick was sun-dried on large, level, sanded fields. The brick, still in molds, was taken on small hand trucks out to the fields. Through new technology, this method was abandoned. Coal, oil, and gas-fired drying sheds increased production capacity to more than a million bricks per day. One of the original drying fields is shown here *c.* 1880.

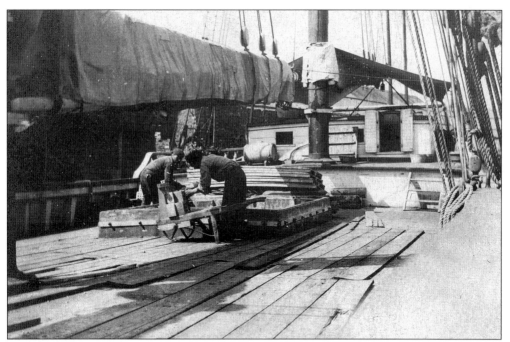

This *c*. 1885 scene shows a schooner at the Sayre & Fisher dock along the Raritan River.

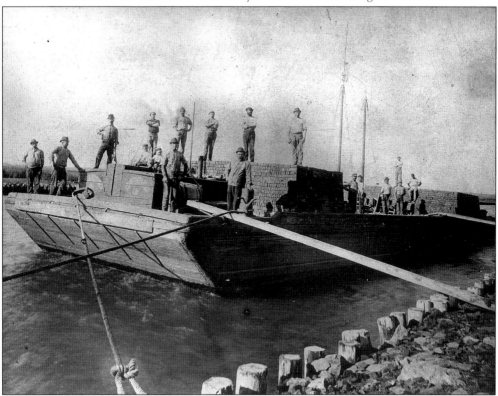

A barge crew takes a break *c*. 1880 while waiting for a tugboat to transport a shipment of brick down the river to market.

Around 1926, stock was issued in the Sayre & Fisher Brick Company, the corporation formed following the sale of the Sayre & Fisher Company to a Chicago utility group. However, the new company was unable to meet its interest obligations and was forced into bankruptcy. It operated under a trustee until 1943, when reorganized as the Sayre & Fisher Company Inc.

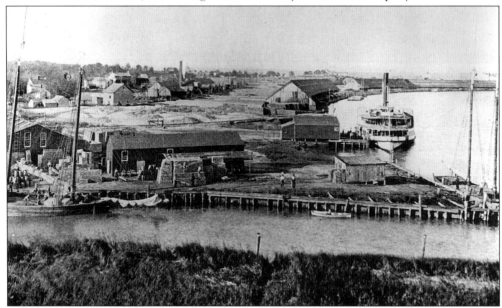

This is the dock of the Whitehead Brothers Company of New York. Much of the company's tracts contained deposits of valuable molding sand, a requisite of the pattern industry. The company ceased operations in the mid-1960s. The excursion boat *New Brunswick*, shown here c. 1900, made day trips between New Brunswick and New York, carrying both passengers and freight. Round-trip tickets were 50¢. The boat burned to its waterline in 1902.

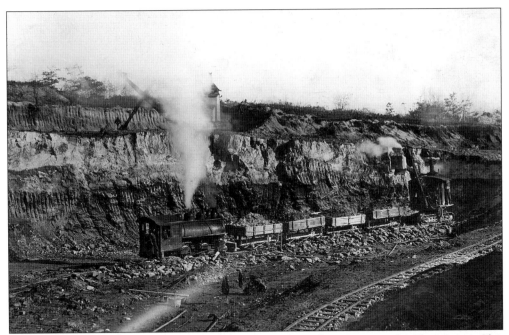

Clay pit mining was a common activity in the early 20th century at the New Jersey Clay Products Company, located at Jernees Mill Road. Remnants of the company now house Viking Marine Terminal.

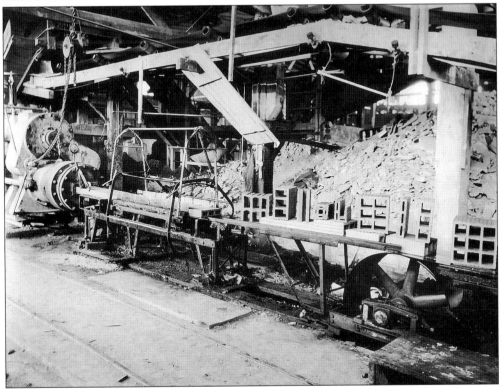

This vintage production line pressed clay into the company's hollow-tile building products.

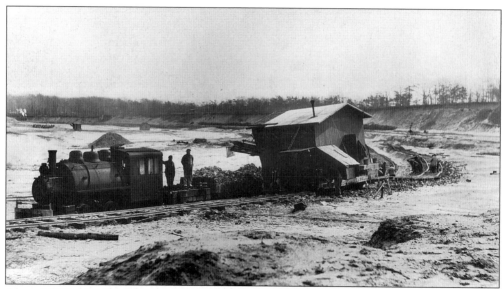

Around 1903, the Crossman Company incorporated as a miner and processor of sand and clay. The Crossman family had acquired lands rich in clay deposits that stretched from the Raritan River upland to what is now Ernston Road and beyond. The holdings included the 100-acre site on which the high school, middle school, and library complex stands today. Crossman's most important product was high-quality sand; its clay was also of a superior grade and was sold by the bag.

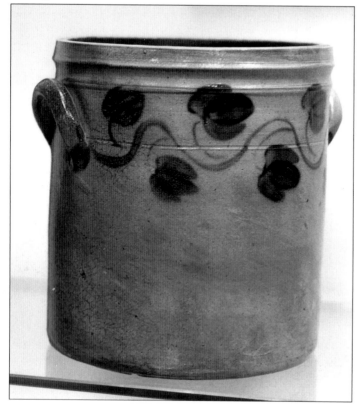

In 1802, Ebenezer Price Jr. and Xerxes Price established a pottery at the southernmost point of the Roundabout, an area known as French's Landing. The family included at least five pot maker craftsmen who produced utilitarian "redware" and stoneware from clay sources near Cheesequake Creek until 1843. Typical of early stoneware, this gray, salt-glazed, five-gallon crock is attributed to Abial Price. It dates from c. 1840 and is decorated with brushed cobalt blue swags.

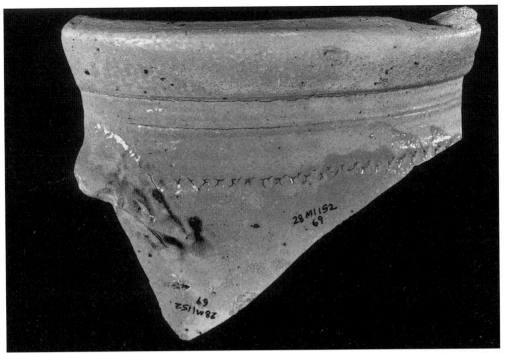

This jar rim shard, c. 1820–1860, was found at the 1990 Winding River archaeological dig of the Price Pottery site. The maker is identified as either the Price family or James Holmes, a small-scale potter who, between 1843 and 1851, operated Price Pottery. By 1829, Price was financially troubled. Half a century after its founding and after the pottery was discontinued, family heirs sold the 27-acre property to James Sayre and Peter Fisher for $4,000. It is at this site that the Sayre & Fisher brick works was constructed.

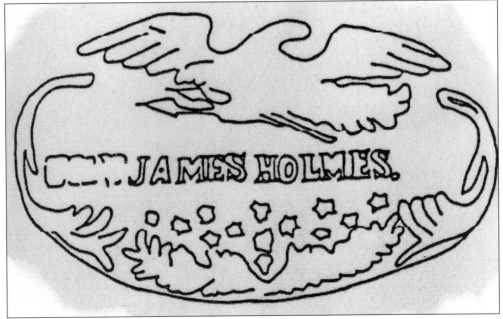

James Holmes pottery, c. 1843–1851, was impressed with this identifying mark.

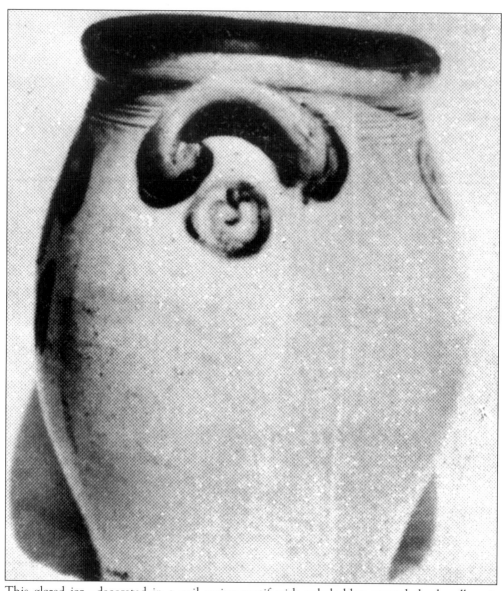

This glazed jar—decorated in a coil spring motif with cobalt blue around the handles—is attributed to the Morgan Pottery. Capt. James Morgan, a Revolutionary War veteran, owned one of the earliest stoneware potteries in New Jersey, dating to 1775. Clay from the Morgan banks was of the finest stoneware clay and supplied local as well as mid-Atlantic and New England potters. The Morgans were one of the most prominent area families. Capt. Morgan commanded in 2nd Regiment from Middlesex County and served as captain in the state troops. He married Margaret Roetus Evertsen, who bore him two sons and eight daughters. Born in 1734, Morgan died on February 26, 1784; Margaret died in 1827, "aged 96 years, 9 months and 21 days." They are buried in a secluded family burial ground at Morgan Manor overlooking Raritan Bay. The small graveyard is all that remains of the Morgan plantation Sandcombe (dating to 1703), which at one time encompassed more than 1,000 acres along Cheesequake Creek.

Two

HOUSES OF PRAYER
AND WORSHIP

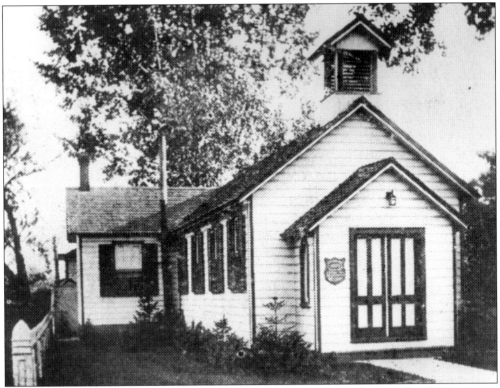

In 1883, the one-story, wood-framed Union Chapel was built at Washington Road. This quaint chapel was founded and supported by Charles W. Fisher. For many years, the Danish Lutheran congregation held services and Sunday school classes here. Although somewhat altered, the chapel still stands today as a private residence.

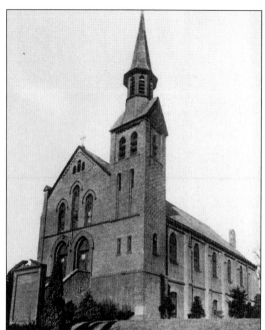

Our Lady of Victories Roman Catholic parish at Main Street had a modest beginning in 1876, holding services at various homesteads. The parish was founded in 1885 and a church was built in 1889. The original church building, shown here, was torn down and the present church was constructed in 1957. Early parishioners were German and Irish immigrants who worked in the township brickyards.

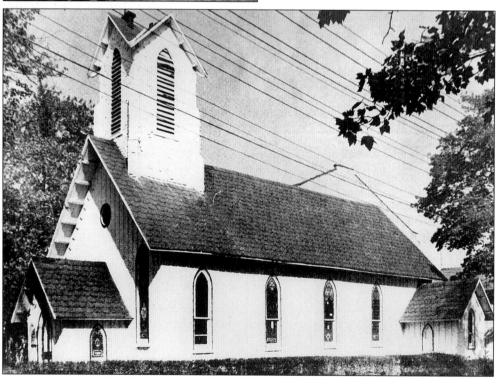

This is a photograph of Holy Trinity Chapel at the corner of Quaid Street and Idlewild Avenue in 1861. Episcopalian services were held in a schoolhouse in 1859 until the chapel was completed two years later at a cost of $1,000 on land donated by William Van Deventer. The structure was moved to its present site at Whitehead and Martin Avenues in South River in 1867. The building today houses the Burning Bush Church of God in Christ.

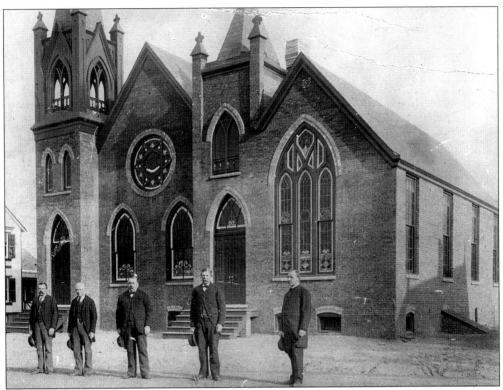

The First Presbyterian Church was founded in 1881 as St. John's German Presbyterian Church. Two years later, the original church building, affectionately referred to as the Old Chapel, was built at 454 Main Street. In 1896, the congregation moved to 174 Main Street and, in 1930, the church was renamed. The building shown here was demolished in 1971, and a larger church was constructed on the same site.

The United Methodist Church, located on Main Street, was built in 1869. Originally named the First Methodist Episcopal Church, the church was established in 1848 and is Sayreville's oldest organized congregation. Services were first held in private homes. The church building, shown here, is built of Sayre & Fisher red brick and has changed little in appearance except for the removal of the spire. The Fishers were active members and benefactors.

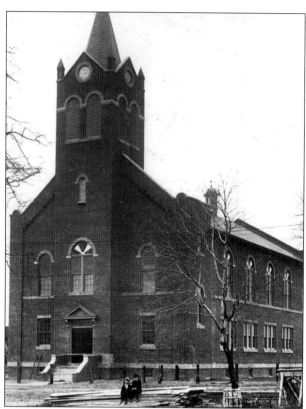

Sayreville's Polish-American community was without a parish until the founding of St. Stanislaus Kostka Roman Catholic Church. A combination church and school was built in 1914 on property donated by Mr. Fisher at McArthur Avenue (then Sandfield Road). Classes were held on the first floor for nearly 50 years until a new school building was erected. The church has since been extensively renovated.

When it was founded in 1958, the Messiah Lutheran Church, located at 3091 Bordentown Avenue, was noted for having the largest charter membership in the New Jersey Synod. The Reverend Gustav A. Westerfeld was pastor at that time.

Three

MAIN STREET AND BYROADS REVISITED

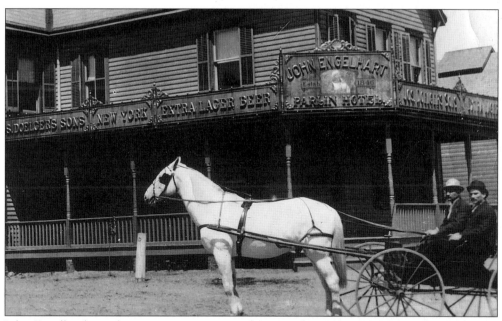

John Engelhardt—police commissioner, township recorder, justice of the peace, and borough councilman—purchased this hotel and bar in 1915 from August Rohde, who had purchased it from Charles and William Whitehead in 1914. The Parlin Hotel was one of seven taverns in Sayreville at the beginning of the 20th century. Although remodeled, the building still stands at the corner of Washington Road and Pulaski Avenue. It has had many incarnations since it was established in 1846, having served as a popular carriage stop, neighborhood pub, and apothecary. Today the building is a professional office and second-story apartment. The building to the immediate right of the photograph is a stable. Note the family name was shortened to fit on the hotel sign. Shown here are John and Charles Engelhardt.

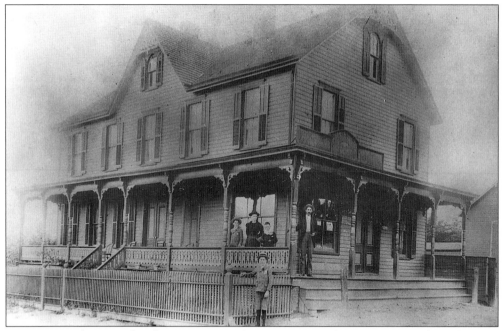

Here is an early view of Miller's Corner at the intersection of Main Street and Washington Road. When Main Street proper was first laid out (*c.* 1872), among the few houses along its way was Unkel's Hotel, on the George Daw property. It later became Jacob Miller's hotel, shown here. The structure was razed, and the corner property is now the site of a professional building.

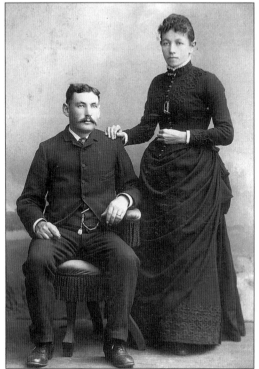

Jacob and Julie Weck Miller are in this *c.* 1915 studio photograph. Julie married Jacob Miller two years after immigrating to the United States *c.* 1911. (See page 8.)

This view shows Walling Street at the beginning of the 20th century.

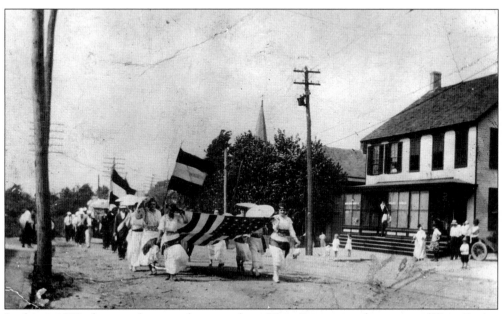

In this *c.* 1900 photograph, a parade proceeds up Main Street near the corner of Haag Street, passing Syslo's tavern (now a Chinese restaurant). The steeple of St. John's German Presbyterian Church is visible in the background.

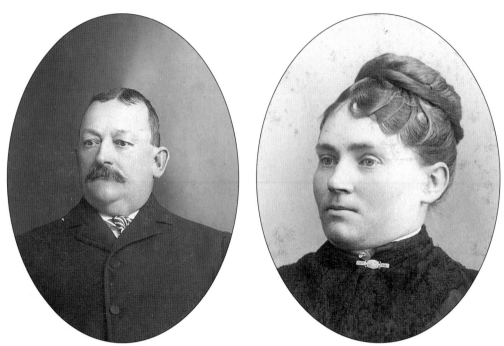

Joseph and Mary Andres Allgair's hotel was a landmark for many years. The Allgairs also operated a bottling company near the hotel. A pavilion was located directly behind the hotel, where wedding receptions and other festive celebrations were held.

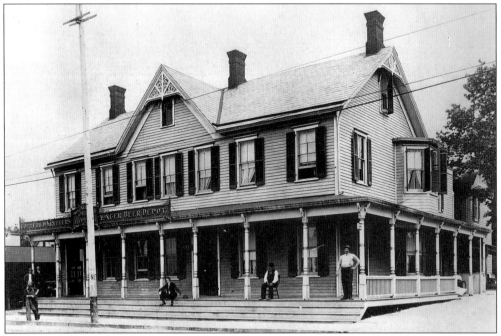

Allgair's Hotel, also known as the Central Hotel and Beer Depot, was located at the corner of Main and Allgair Streets. In early days, Sayreville's hotels and taverns played an important role as centers of political activity. Township council meetings were recorded as having been held at Joseph Allgair's hotel.

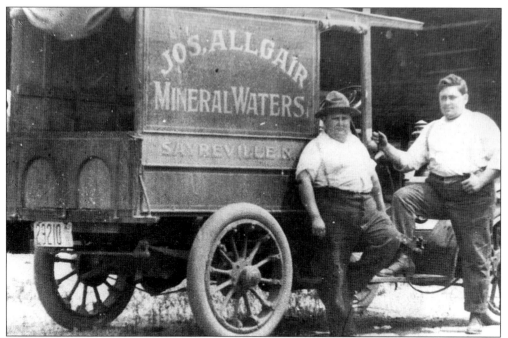

Joseph Allgair's Mineral Waters delivery men pose c. 1910 while awaiting their orders for the day.

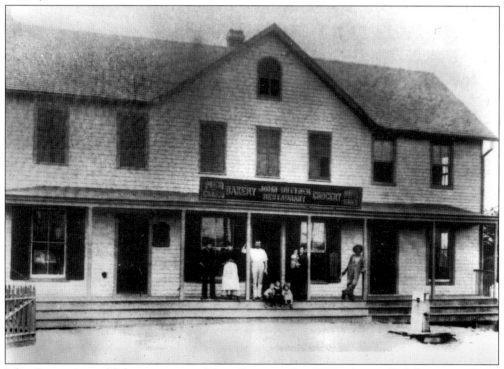

John Buttner's establishment was on Main Street in the 1890s. August Rohde, an employee of Buttner, purchased the business in 1898. Shortly thereafter, it became August Rohde's Peoples Hotel.

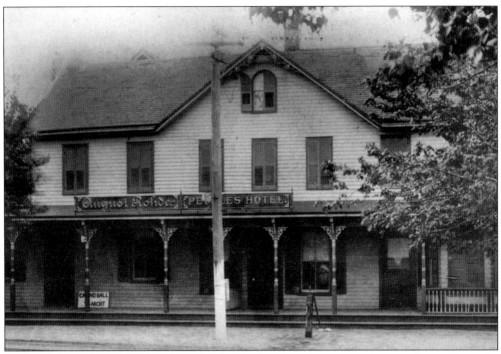

August Rohde's Peoples Hotel was one of seven hotels and meeting places in Sayreville at the beginning of the 20th century. In addition to the tavern (left) and the bakery (right), Rohde bottled Jacob Hoffman Brewing Company's Saazer-style beer. The building is currently the site of Maliszewski's Memorial Home.

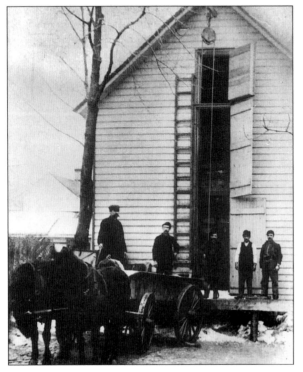

Rohde's Ice House, shown *c.* 1900, served the populace for many years. Blocks of ice would be loaded onto the horse-drawn carriage and would be cut to the homeowner's specifications. As the ice melted, it would drip into a pan at the bottom of the icebox, which had to be emptied frequently.

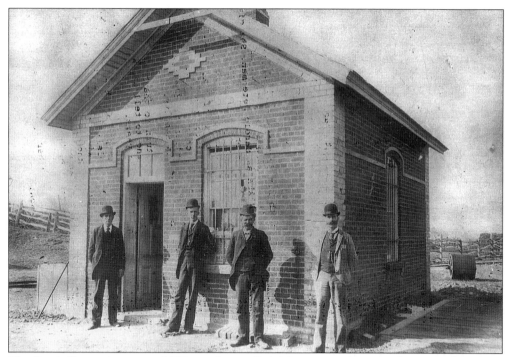

The first jailhouse in town *c.* 1906 was August Rohde's converted carriage house on the corner of Main and Dane Streets. It was used primarily to lock up rowdy revelers, who would be released in the morning after a good night's sleep.

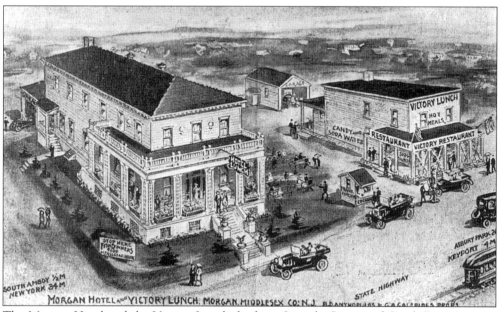

The Morgan Hotel and the Victory Lunch, both on Lincoln Street and South Pine Avenue, are depicted in this *c.* 1920 drawing. B.D. Anthopulos and G.A. Galepides were the proprietors of these establishments. The stately Morgan Hotel, now Ted's Tavern, has housed an inn or tavern for more than a century.

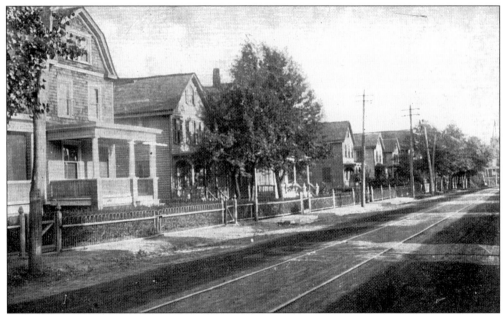

Main is a street for all seasons. These images show tree-lined Main Street in the summer and again following an old-fashioned snowstorm. The steeple faintly visible in the distance is that of St. John's German Presbyterian Church. Note the trolley tracks running down Main Street.

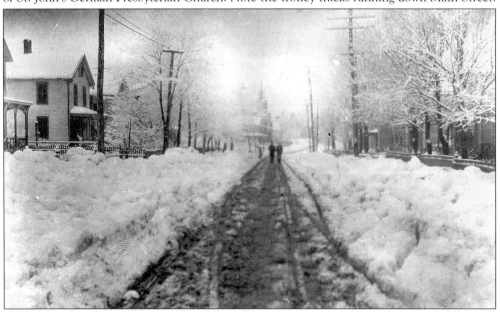

Presumably this is John Haag, proprietor, and his family standing in front of his grocery store and bakery on Main Street across from the town hall in this *c.* 1920 photograph. The bakery was contained in buildings in back of the store. The business was sold in 1922 to Joseph and Stella Poplowski and continued as a family operation until 1944, when sole ownership was assumed by Joe and Jean Poplowski (Joseph's son and daughter-in-law). In 1951, new owner Joe Albin opened Albin's Market and remained there for 19 years. The site, somewhat altered, today houses a beauty salon.

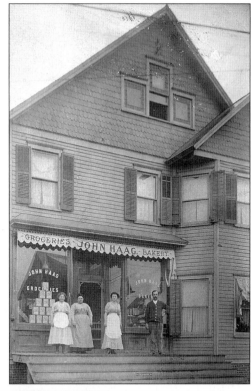

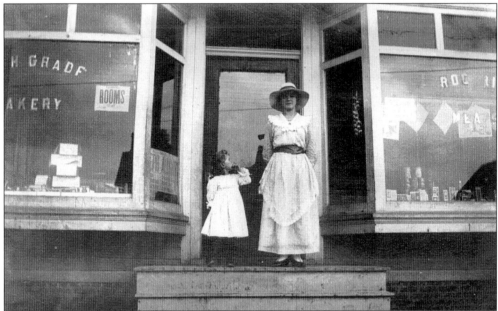

The High Class Bakery, Grocery Store, and Meat Market was established by Walter Paluch in this brick building on lower Main Street. In 1926, the business was sold to Theodore Gutkowski, whose Sun-Glo Bakery quickly became one of the most popular bakeries in Sayreville and surrounding communities. Again under new ownership, the bakery continues as a successful area business. Paluch's daughter Henriette is the young girl in this *c.* 1890 picture.

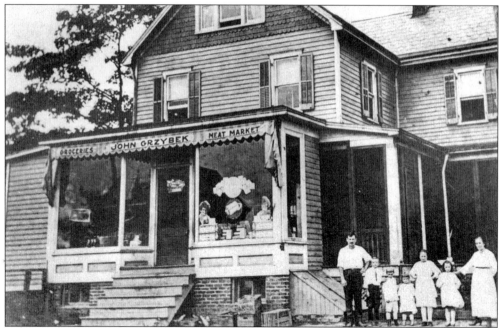

John Grzybek's grocery and meat market was located on the corner of Washington Road and Pulaski Avenue. Grzybek is shown *c.* 1925 with his wife, Katherine, and children John, Edward, Pearl, Mary, and Roselind. Roselind became an elementary school teacher in Sayreville. The structure today houses a funeral home.

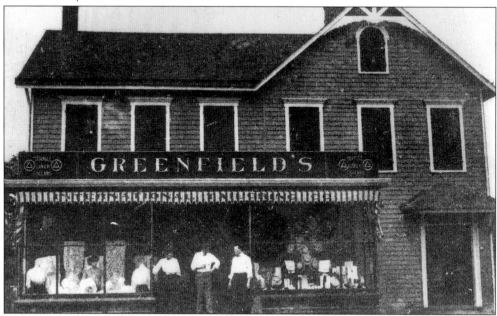

Adolf Greenfield opened his department store on Main Street in 1905. When he died in 1941, his son Morton took over the business. Later he was joined by his brother-in-law Albert Wallen. For 75 years, the Greenfields operated the store, which retained its original charm with an embossed tin ceiling and antique cash register. At least three generations of townspeople shopped here.

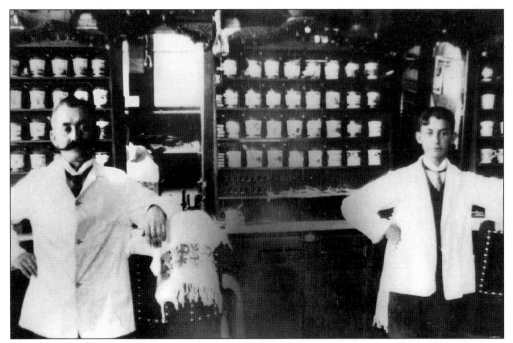

Fred Werner's barbershop in the early 1900s boasted hot towels and two chairs. It was located on Main Street next to Greenfield's Department Store. Note the individually owned shaving mugs lining the back wall.

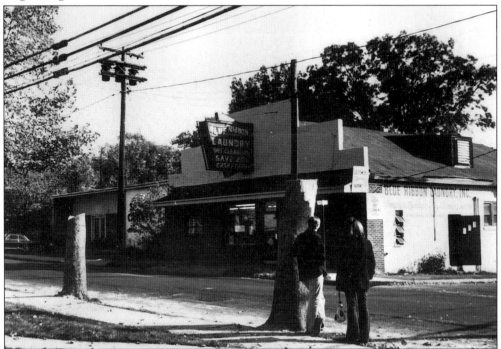

The Blue Ribbon Laundry (known as the Nonpariel Laundry in the 1920s) was located on the corner of Washington Road and Reid Street in Parlin. It was a precursor to the self-service laundromat. The laundry was torn down and replaced by the Amboy National Bank.

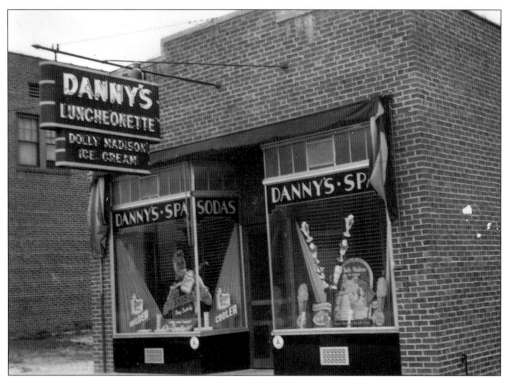

Danny's opened in the early 1940s, at about the same time as the opening of Sayreville High School. Students spent their after-school hours here, enjoying ice cream or a hamburger and Coke for 25¢. A doctor's office now occupies the building.

A strip of c. 1935 storefronts at 61–67 Main Street has been remodeled and is now the Karcher Building. The Bissett Pharmacy once occupied the building to the immediate right.

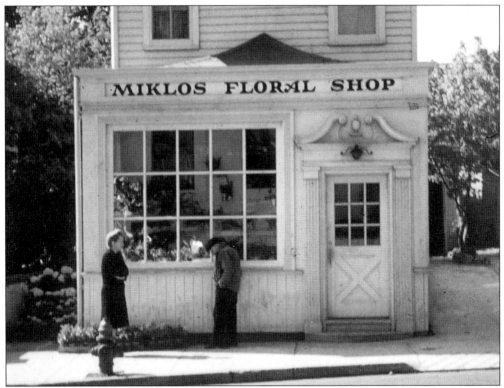

Miklos Floral Shop, a community first, was established in 1946 at 218 Washington Road. Although the house still stands, the family business moved across the street to 215 Washington Road. Proprietor Helen Miklos is pictured in front of the original shop.

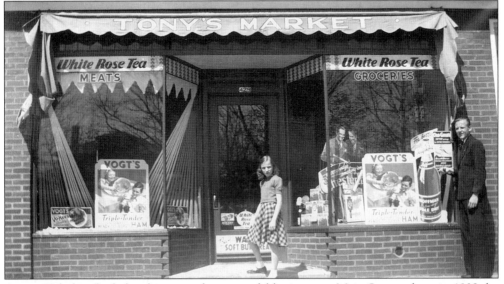

Anton Kolodziej had already operated a successful business on Main Street when, in 1932, he and his wife, Mary, opened Tony's Market at 429 Washington Road. The store and residence was built by local contractor William Albert. Today it houses professional offices. Shown in 1938 are Kolodziej's daughter Rita and son Edwin.

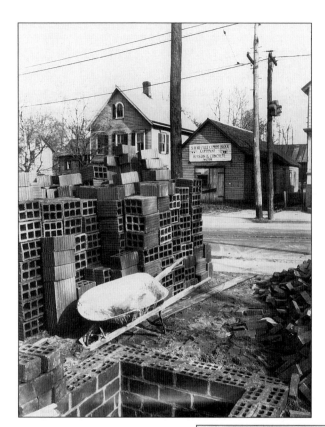

The Sayreville Cement Block Company, at 70 Main Street, later became a hardware store, fish market, and then an auto repair shop. Note the trolley signal on the pole.

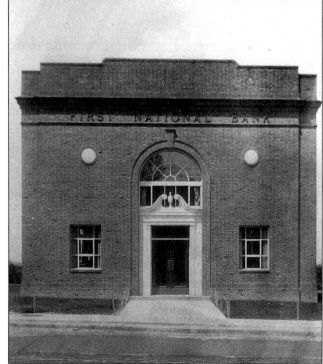

The First National Bank of Sayreville was organized in 1929 and was one of the leading financial institutions in the county. Located in the heart of town on Main Street, the building now houses the Penn Federal Bank.

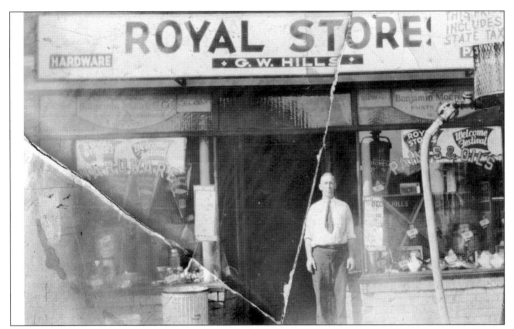

The Royal Store (*c.* 1930), at 125 Main Street, was more commonly known as Hills Hardware. George W. Hill, the proprietor, stands in the doorway. The hardware store was used as a Sayreville post office and substation. It now houses Main Hardware.

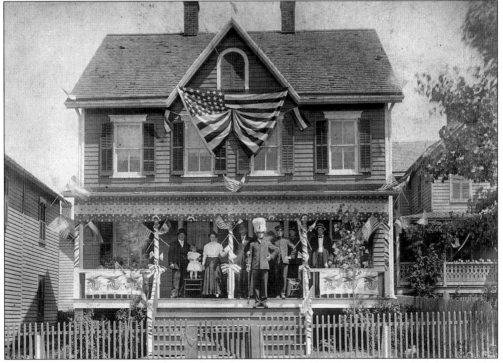

This Main Street home is festooned in red, white, and blue for a summer holiday *c.* 1900. Among parade participants posing on the porch is a drum major with baton in hand. Today, the house stands across the street from the building that once housed the town cinema.

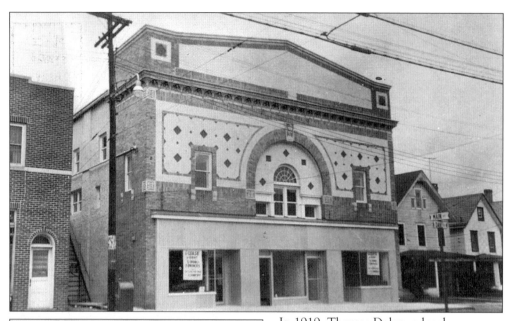

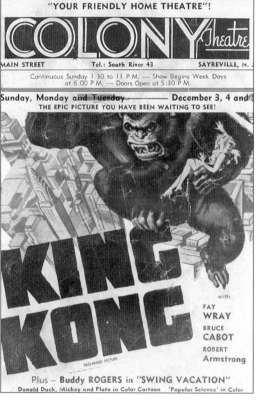

"YOUR FRIENDLY HOME THEATRE"!

COLONY Theatre

MAIN STREET Tel.: South River 43 SAYREVILLE, N. J.

Continuous Sunday 1:30 to 11 P.M. — Show Begins Week Days
at 6:00 P.M. — Doors Open at 5:30 P.M.

Sunday, Monday and Tuesday —————— **December 3, 4 and**
THE EPIC PICTURE YOU HAVE BEEN WAITING TO SEE!

KING KONG

with
FAY
WRAY

BRUCE
CABOT

ROBERT
Armstrong

RKO-RADIO PICTURE

Plus — **Buddy ROGERS** in **"SWING VACATION"**
Donald Duck, Mickey and Pluto in Color Cartoon 'Popular Science' in Color

In 1919, Thomas Dolan, a local contractor who later became Sayreville's fourth mayor, built the Liberty Theatre on Main Street. Silent films and live piano music were featured. In the 1930s, it reopened as the Colony Theatre, a program of which is shown to the left. Free 22-karat, gold-trimmed dinnerware was distributed to every female patron on Wednesday and Thursday evenings. This building, minus the marquee, now houses varied businesses.

40

One room in a former store at 66 Main Street served as the first Free Public Library. It was founded in 1931 by a group of local citizens. In 1968, it moved to larger quarters in the borough hall. In 1971, a new library was constructed on Washington Road.

Victorian Hall was constructed in 1920 on the grounds of Our Lady of Victories Church. It served for many years as a community and church center. The site today is the home of a new parish center dedicated to the memory of Msgr. Edward Dalton.

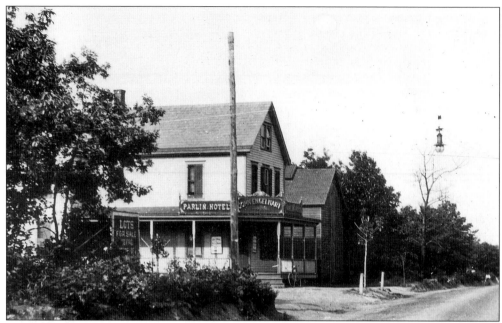

The principal highway through Sayreville ran from Washington (now known as South River) to South Amboy and was called Washington Road. This photograph, taken *c.* 1900, shows Washington Road at Pulaski Avenue and the Parlin Hotel. South Pulaski Avenue was yet to be laid out. The sign at the left advertises lots for sale.

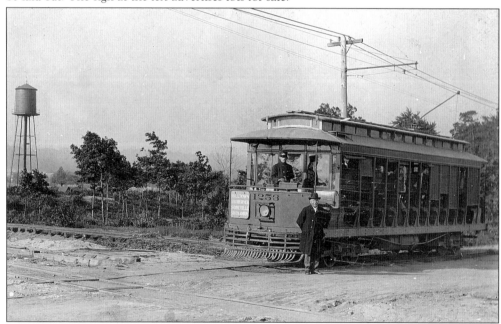

Middlesex and Somerset Traction Company began trolley service in Sayreville in 1901, connecting New Brunswick and South Amboy. Original rail ties buried beneath Main Street (between Washington Road and MacArthur Avenue) were removed in 1999. Robert Stier, pastor of St. John's German Presbyterian Church, is pictured in 1910 before boarding one of the early trolleys on the first leg of his journey to Japan.

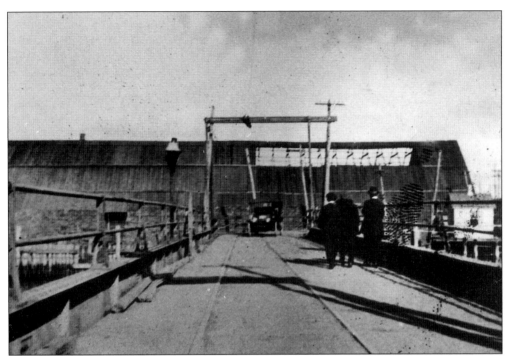

The original Sayreville-South River drawbridge was built in 1860 by Daniel B. Martin and Zenas Van Deventer. Note the bridge tender's house on the right. The structure survived 54 years before it was replaced by a sturdier steel and concrete drawbridge in 1914 (below).

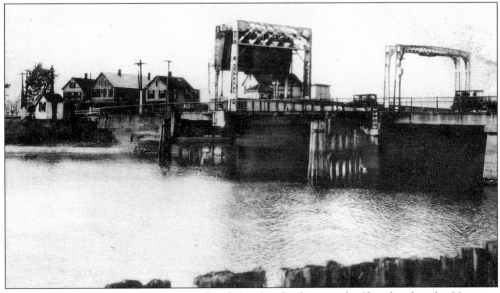

The ravages of time and weather rendered the drawbridge unsafe. Shortly after the Veterans Bridge was opened in 1974 (more directly linking Washington Road and South River's Main Street), the drawbridge was demolished.

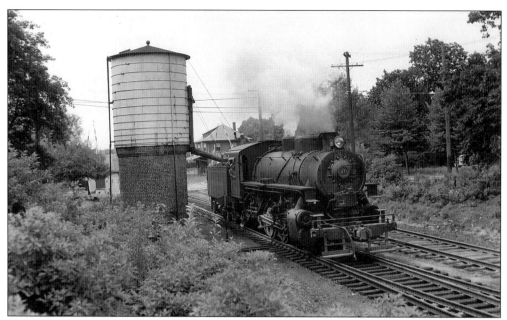

Raritan River Railroad engine No. 21, a war surplus U.S. Army locomotive, takes on water at the water tower off Washington Road in this 1949 photograph. Visible in the background is the Raritan River Railroad, Parlin freight station.

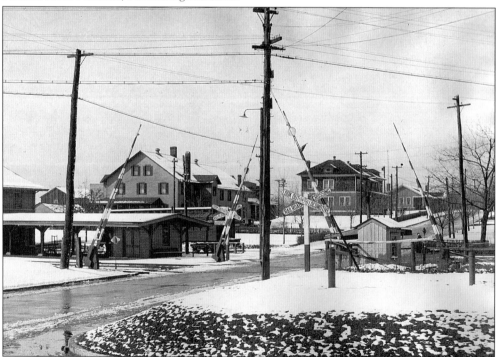

This winter scene, looking west, shows Washington Road at the Parlin station crossing. The large building at the left was the Parlin Clubhouse, built by E.I. duPont to accommodate business guests. The second building was a boardinghouse for single men who worked for the company. Sold to private owners in the 1950s, the buildings are still used as rooming houses.

Richard and Fred Muschick were the owners and operators of the Muscatt Manufacturing Company, an embroidery factory located off Washington Road on Embroidery Street. Shown here c. 1900, it later became a pajama factory. After fire gutted the second floor, it was rebuilt as a one-story factory and today houses Sports King. The Fred Muschick family lived in the Queen Anne–style house that adjoins the Miklos Floral Shop.

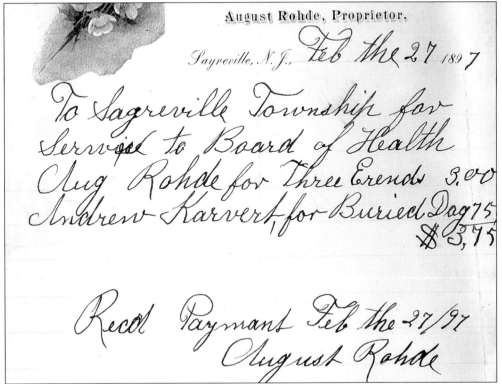

August Rohde submitted this bill c. 1897. Notice the cost of a pet burial: 75¢.

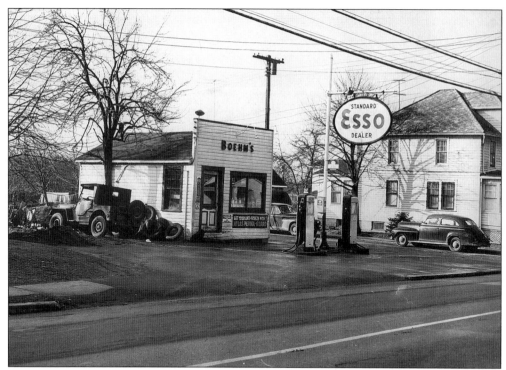

Boehm's Esso, located at the corner of Washington Road and Winkler Avenue, was constructed in 1928 by partners J. Henry Boehm and Edward Fritz. It remained in operation until 1949, when a larger facility was built by Harold Boehm. In 1960, the property was sold and today houses an auto repair shop.

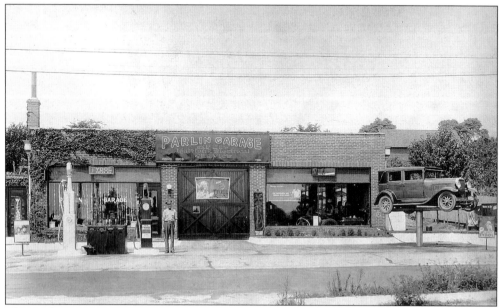

The Parlin Garage (c. 1925) on Washington Road in Parlin was owned and operated by Theodore Unkel, who is pictured here. Built shortly after the end of World War I, the building is still used as an automotive repair shop.

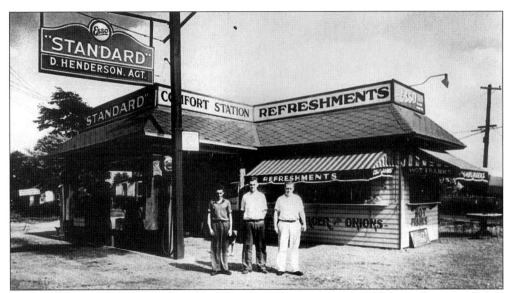

Daniel Henderson's Esso service station was located on the corner of Route 35 and Old Spye Road in Morgan. It also served as a hot dog and hamburger stand. Prior to 1937, Route 35 was a two-lane highway.

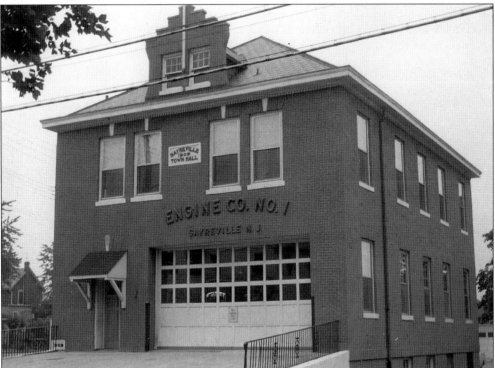

The Sayreville Town Hall, built in 1909–1910, was the first municipal building and was also used for additional classroom space in 1913. The first fire company was founded in 1916 and shared these quarters with the town government for 26 years. The volunteer firemen of Engine Company No. 1 became the sole occupants of these headquarters when a new municipal building was erected in 1942.

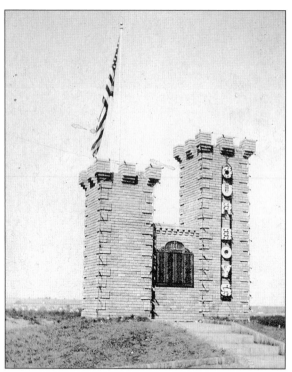

Soldier's Monument was erected in 1919–1920 to honor veterans of World War I. Designed by the Reverend William A. Gilfillan (former pastor of Our Lady of Victories Church) and built by local men with local materials, it stands at the south end of the borough hall.

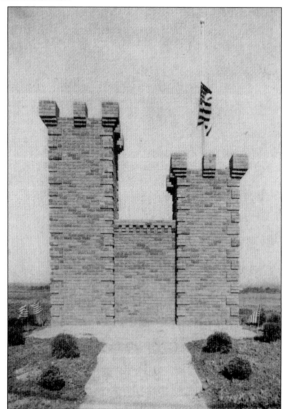

In 1946, a replica of the original monument was dedicated to residents who served in World War II. The War Memorial Monument is constructed of brick donated by the Sayre ,& Fisher Company Inc. and stands at the north side of the municipal building.

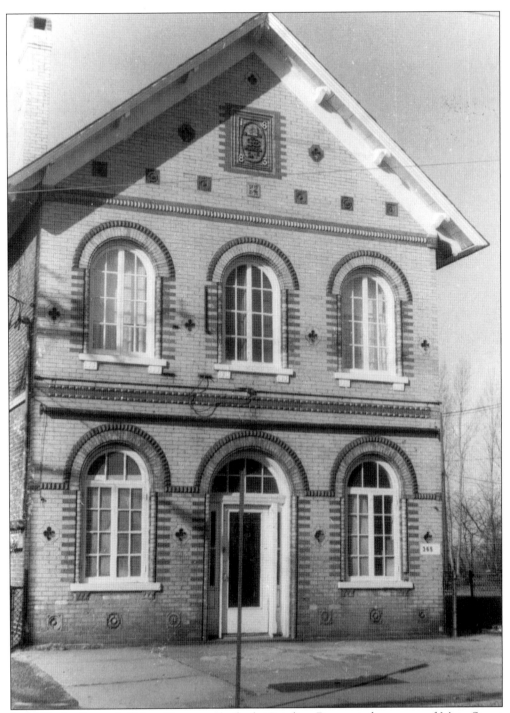

In 1883, the Sayre & Fisher Company built the Reading Room at the corner of Main Street and River Road as a library and community center. It is an excellent example of the varied types and colors of brick the company produced. Today the ground floor is used as a general store, and the second floor has been converted into apartments. The Reading Room is listed in the New Jersey and National Registers of Historic Places.

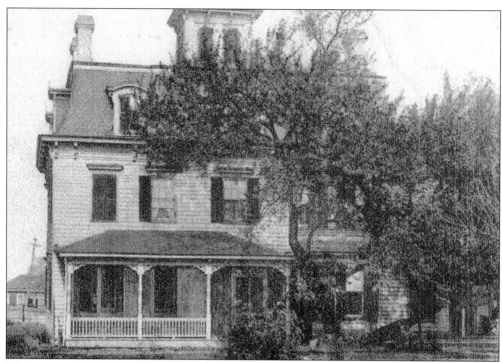

With a tower and a mansard roof, the Peter Fisher residence, c. 1870, was an excellent example of Victorian domestic architecture.

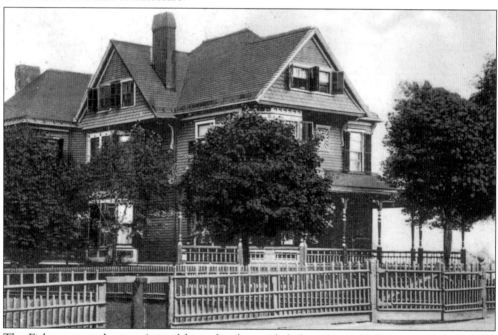

The Fishers, once the town's wealthiest family, resided along lower Main Street. E.A. Fisher's home, although remodeled, looks very much today as it does in this c. 1908 postcard. It was customary among the gentry in the early 20th century to have photographic postcards of one's residence that could be used as note cards.

In this *c.* 1900 backyard view, the building third from the right is today the Sayreville Bar and Restaurant, located at 7 Cecelia Street.

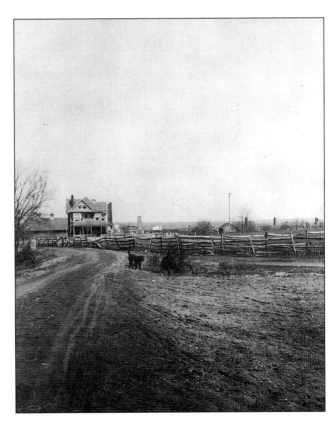

Photographed *c.* 1860, the earliest Fisher homestead later became the E.A. Fisher home.

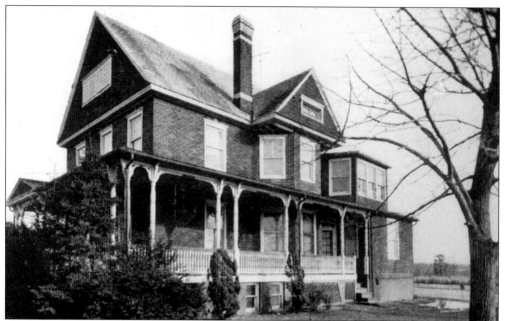

Early in the 1930s, the Knights of Columbus Council No. 2061 purchased the old Charles Fisher homestead on Washington Road and Bissett Streets. The building was renovated and used as a clubhouse until 1962, when the Knights moved into their newly constructed facility in Parlin. The old building was subsequently destroyed by fire.

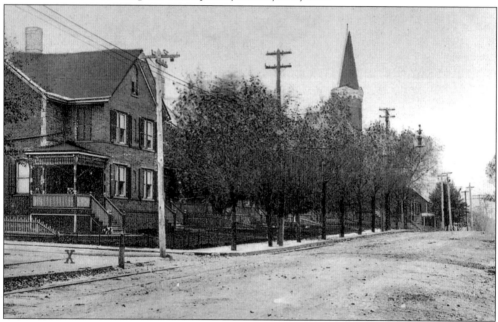

This brick dwelling at the corner of Main Street and Pulaski Avenue is one of four built by the Sayre & Fisher Company for its executives. It was the Willis Fisher residence early in the 1900s. Amenities included servants' quarters on the third floor and running water piped in from a nearby well. Victorian gingerbread graced the gables. These homes still stand along lower Main Street.

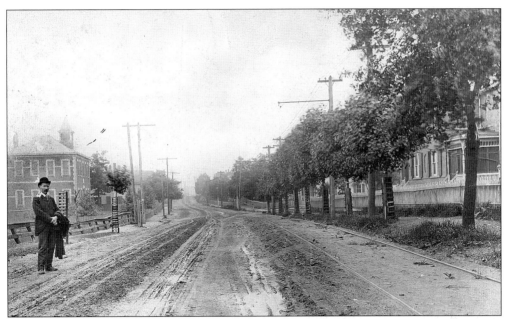

This view, taken at the corner of Main Street and Pulaski Avenue at the beginning of the 20th century, shows an unpaved, tree-lined street of well-appointed homes. New School No. 1, with cupola, stands on the left; today it serves as the Sayreville Historical Society Museum. Philip Farley, a local contractor, built 20 homes in and around this neighborhood.

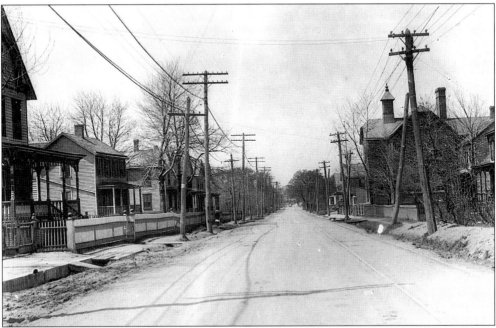

This c. 1915 view of Washington Road looks west toward South River. The building topped by a cupola is the Lincoln School. Most of the homes in this photograph are still standing, but the school has long since been demolished. Notice the trolley tracks on the right and the drainage ditches on either side of the road.

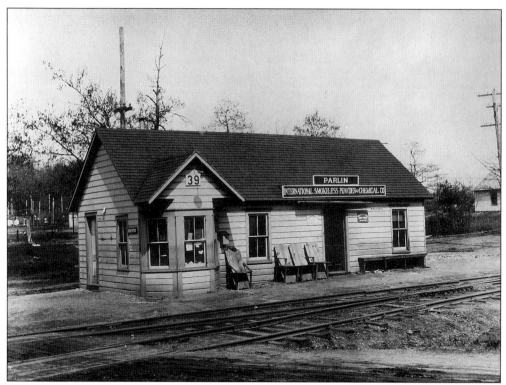

The Parlin station was a busy place in 1900, handling passengers, mail, and freight. Passengers were boarded here for transfer to the New York Line in South Amboy. This building also housed the first Parlin post office, established in March 1901, with Edward Dewan as postmaster.

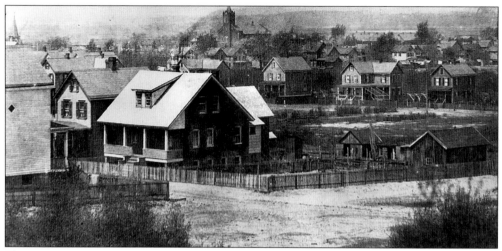

This is Hart Street *c.* 1915. The steeple of St. John's Presbyterian Church can be seen on the extreme left. St. Stanislaus Church is in the center background.

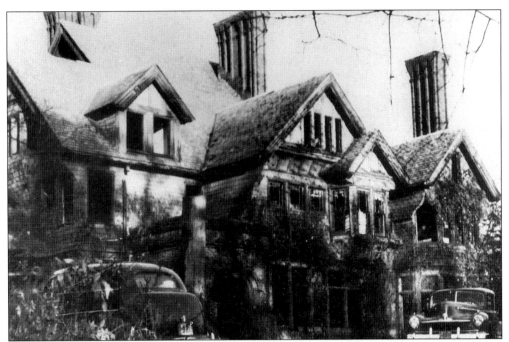

The Such family (Such Clay Company) mansion was a magnificent replica of their English manor house. It was built in 1887 on a knoll off Washington and Ernston Roads at the site of the Woodside development. Among the home's amenities were a 12-foot Italian marble fireplace, cherry woodwork, a large ballroom, dumbwaiters, gargoyles, a tennis court, and servants' quarters. The mansion was extensively vandalized and was subsequently sold, demolished, and salvaged for scrap. War games were held on the property during World War II.

Sayreville-born Edwin F. Lockhart was an assistant treasurer and vice president of the Sayre & Fisher Company. The Lockharts lived in this c. 1925 house on Main Street. The home still stands today.

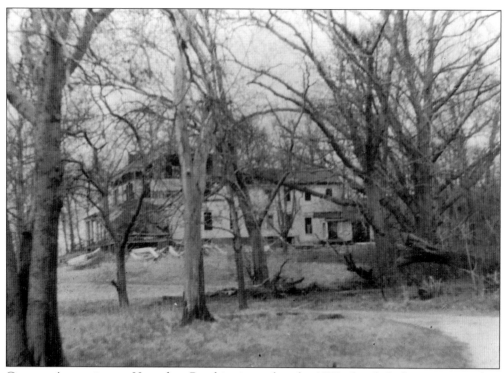

Crossman's mansion on Horseshoe Road is pictured in the 1970s shortly before it was razed.

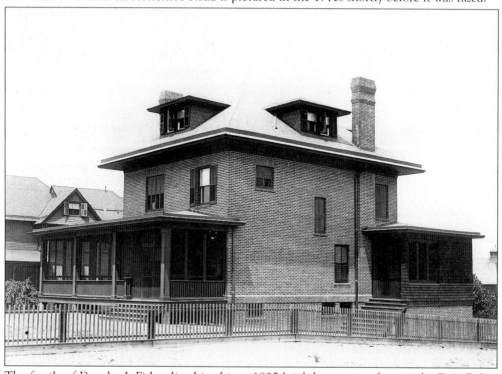

The family of Douglas J. Fisher lived in this *c.* 1925 brick home next door to the E.A. Fisher homestead on lower Main Street. The house is essentially unchanged today.

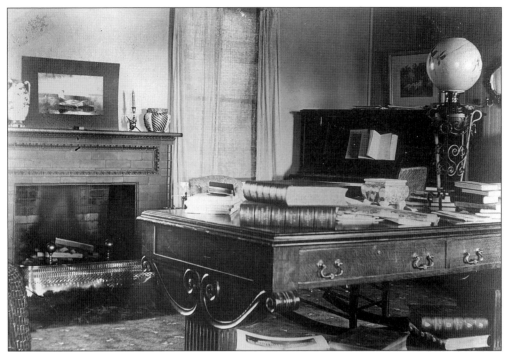

This rare view of a furnished interior, possibly the study, of the Fisher home dates from the 1890s.

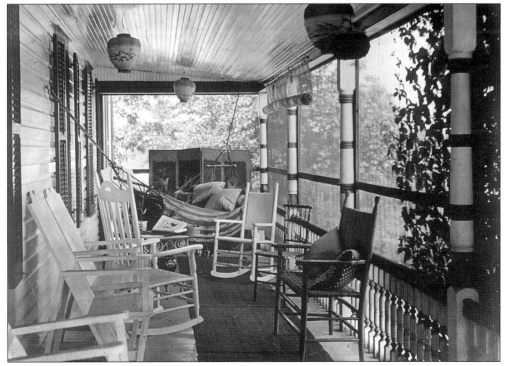

The front porch of the Fisher residence is shown with all the amenities for a pleasant summer room.

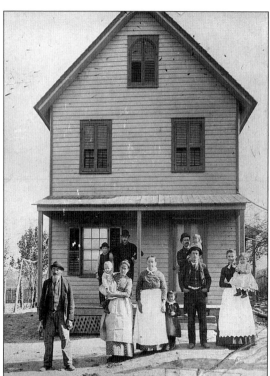

Alois Mark, a boot maker, and his family gathered for this photograph in front of their c. 1880 home, which still stands at 142 Main Street.

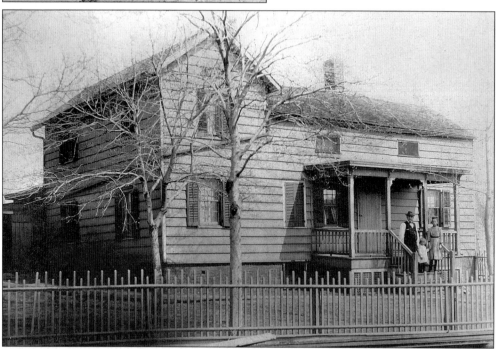

This c. 1900 house with picket fence stood off River Road next to the Sayre & Fisher Company main office for more than 60 years until it was burned to the ground. Philip Bossong, a Sayre & Fisher baker, lived in this company home with his wife, Angela, and family. The Bossongs are pictured on their front porch with their daughter Margie, who later married Casper Boehm.

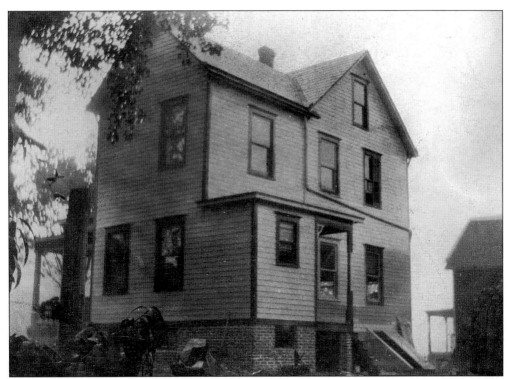

The home of Casper and Margaret Boehm, this *c.* 1910 house still stands at 7 Main Street. Margaret was the first woman to serve on the board of education.

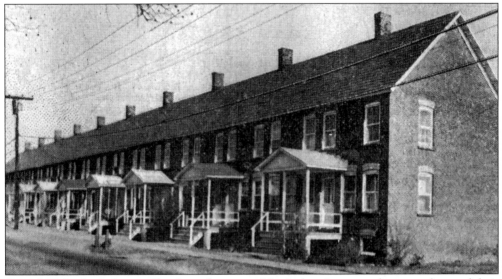

Sayre & Fisher built these red brick row homes on MacArthur Avenue to house workers and their families. A male dormitory was located at the nearby juncture of Jacobsen and Canal Streets.

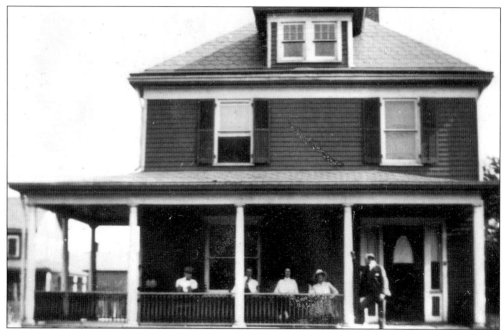

Here is an example of a foursquare house popular in the Depression era. Somewhat altered, the home, with its wraparound porch, still stands at the corner of Washington Road and Walling Street.

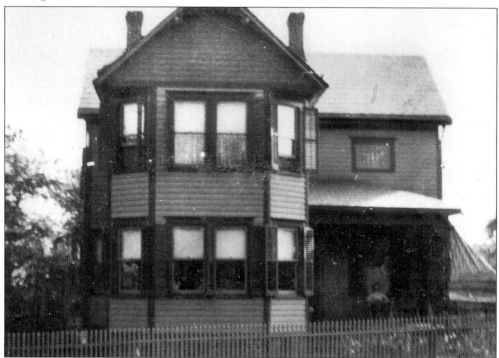

Built by the Smith brothers in the late 1800s, this house on Washington Road is very much the same today. The children on the front porch are identified as Mabel and Dick. Note the grape arbor in back.

Four

READING, WRITING, AND ARITHMETIC

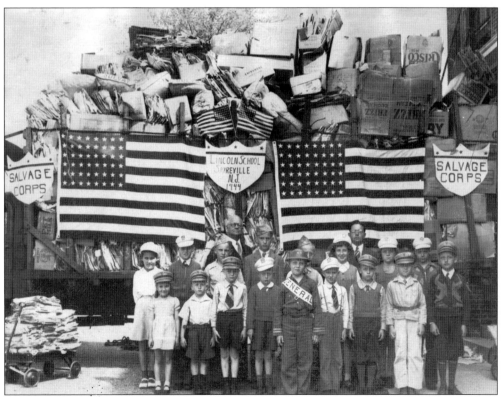

Children of the Lincoln School in the 1940s and their principal, Edward Robinson, pose proudly with·their contribution to the war effort. Newspapers were collected for re-use in defense plants during World War II.

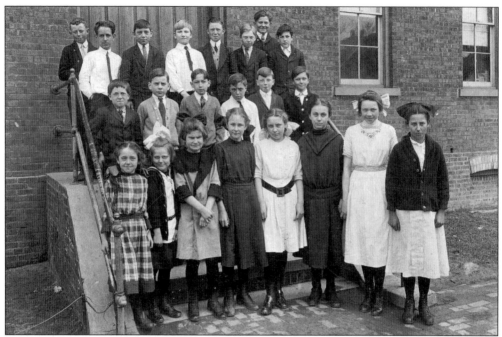

Grade school students at an unidentified school pose for a class picture c. 1915. In early schools, several classes were taught at the same time in one classroom.

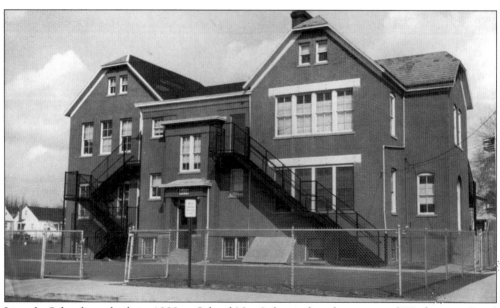

Lincoln School was built in 1888 as School No. 2, located at the corner of Washington Road and Rapplyea Street. Closed to pupils in 1962, it then served as a distribution center for school supplies and has since been demolished.

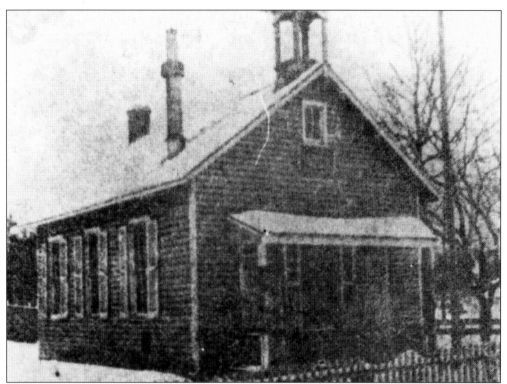

School No. 3, located on Ernston Road, was constructed in 1894 by residents of this section of town. Records indicate the school was in operation until 1918. Late in the 19th century, less than 200 children attended school in the township. Male and female teachers were employed at salaries of $45 and $33 per month, respectively.

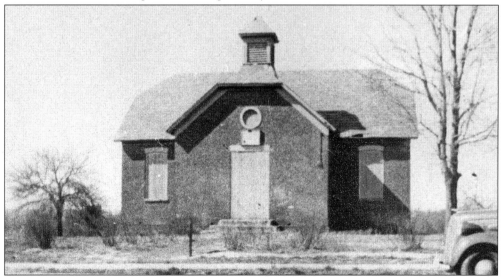

Burt's Creek School (School No. 4) was a two-room building on the north side of lower Main Street near what is now Burnett Avenue. Opened in 1896, it was utilized until its closure in 1903. It was reopened in 1916 in response to shifts in pupil population. The building was demolished in the 1950s.

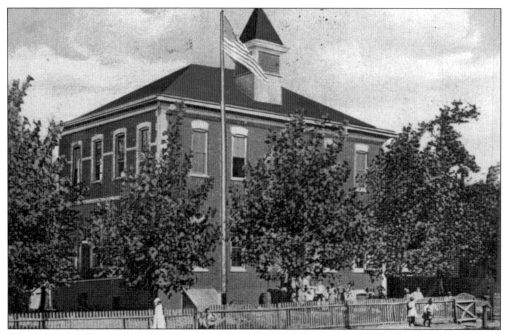

The first schoolhouse in town was located at Quaid Street near the present Wilson School. Both material and labor for the building were contributed by the townspeople. It was in use from 1840 until 1870.

Old School No. 1, Sayreville's second school, opened in 1870 and served the community until 1885. It stood on the west side of Hillside Avenue. No trace remains of the typical, square-frame school known as the Little Red Schoolhouse.

New School No. 1, on lower Main Street, opened in 1886. It subsequently became the Washington School Annex and later served as the offices of the board of education. Since 1984, the Sayreville Historical Society Museum has been housed in this building.

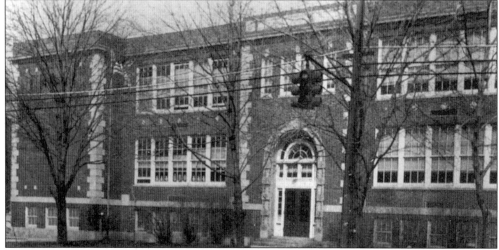

Washington School, opened in 1920, is located adjacent to what was New School No. 1. This facility was the first school erected in Sayreville that taught students at different grade levels rather than together in one space. This building is at the foot of Pulaski Avenue and Main Street. It was enlarged in the late 1950s and currently serves as the Sayreville Senior Center.

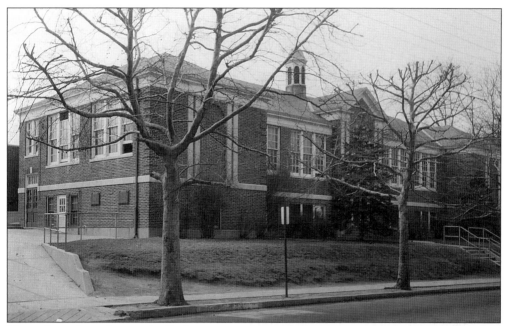

The influx of people into the Parlin section of town led to the construction of the Roosevelt School in 1927. This building—named for Pres. Theodore Roosevelt and located on Washington Road near Minnisink Avenue—was expanded in 1949 and 1959. It has since been demolished, replaced by housing.

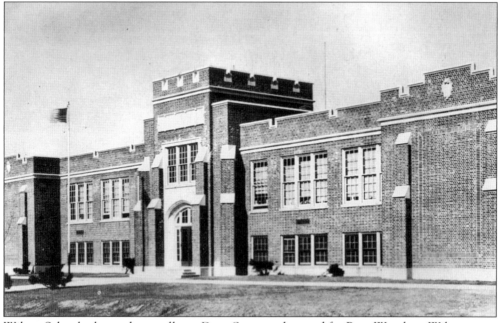

Wilson School—located centrally on Dane Street and named for Pres. Woodrow Wilson—was constructed in 1930. It served as a grammar school until 1939, when it was greatly expanded under the Works Progress Administration program to become Sayreville High School, the first secondary school in town. The building reverted to an elementary school in 1962, following the construction of the Sayreville War Memorial High School.

Jesse Selover Elementary School was constructed in 1954 in the Morgan section of town. The building honors supervising principal Jesse Selover for his years of distinguished service in education.

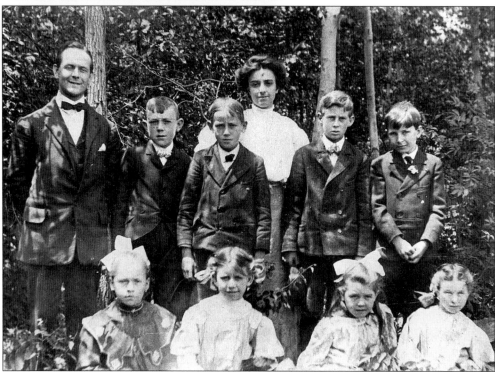

Selover was appointed principal of School No. 1 in 1901. He retired after 43 years of service in the Sayreville school system—5 years as a teaching principal and 38 years as supervising principal. He is pictured here *c.* 1906 with his class at the Lincoln School.

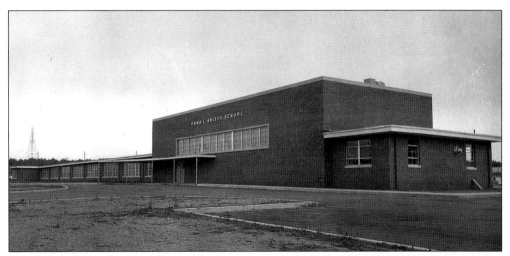

The Arleth School honors Emma L. Arleth for her 43 years of dedicated service as a teacher and principal. The school, on the south side of Washington Road in President Park, opened in 1957. An addition a few years later created the largest elementary classroom facility in the school district.

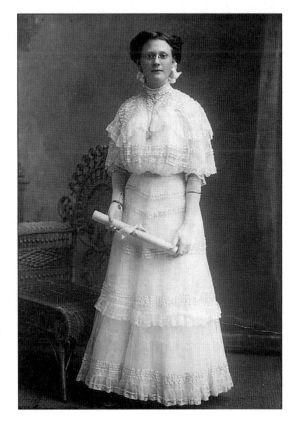

Emma L. Arleth, dressed in white and holding her diploma, posed for this 1907 photograph on the occasion of her high school graduation. She began her teaching career that same year at New School No. 1 and continued her studies at Rutgers University and the New Jersey Normal School.

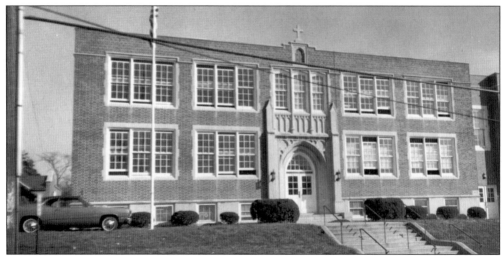

In 1889, Our Lady of Victories parish opened the first parochial school in Sayreville, initially known as St. Mary's and staffed by Franciscan Order sisters. Administration responsibilities were transferred to the Sisters of Mercy in 1895. An eight-room school was completed in 1930 and later modified to meet a growing educational program.

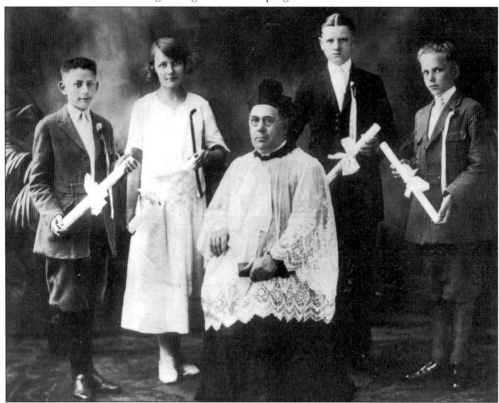

St. Stanislaus Kostka School opened its doors in September 1914. Classes were taught by the sisters of the Felician Order. In 1964, a new school building was dedicated, replacing the original classrooms in the parish building. The Class of 1924 poses here with founding pastor Rev. John Pawlowski.

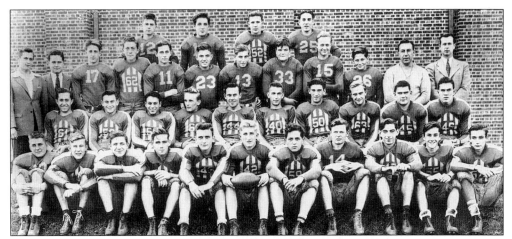

The Blue and Gray Bombers of Sayreville High School rounded out their second season with six wins and one tie. It also boasted the naming of fullback John Kotarski to the 1941 All-County and Group II All-State teams. Football games were held at the now-abandoned Hercules Field at Cheesequake Road; baseball was played at DuPont Field, today known as Burke's Park. Here, coach Vince Abbatiello (third row, second from the right) poses with his winning team for a yearbook photograph.

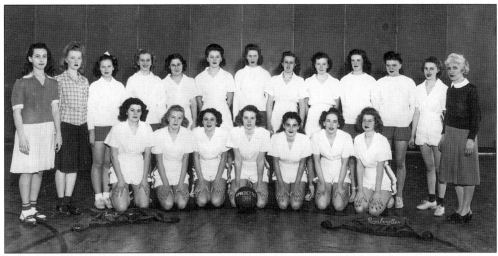

The 1944 girl's varsity basketball team of Sayreville High School assembled for this photograph at the close of their undefeated initial season. From left to right are the following: (front row) Jennie Maciorowski, Florence Prusik, Jane Mansfield, Helen Mansfield, Corinne Lappas (captain), Dorothy Gominger, and Edice Marcy; (back row) Grace Marcy, Sonia Westergaard, Bernice Wnek, Irene Liszka, Miriam Eberle, Rose Krakowski, Claire Stores, Margaret Fritz, Claire Mansfield, Theresa Jaje, Florence Roginski, and Christine Van Tresco (coach).

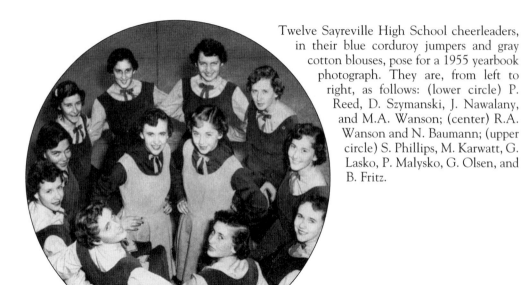

Twelve Sayreville High School cheerleaders, in their blue corduroy jumpers and gray cotton blouses, pose for a 1955 yearbook photograph. They are, from left to right, as follows: (lower circle) P. Reed, D. Szymanski, J. Nawalany, and M.A. Wanson; (center) R.A. Wanson and N. Baumann; (upper circle) S. Phillips, M. Karwatt, G. Lasko, P. Malysko, G. Olsen, and B. Fritz.

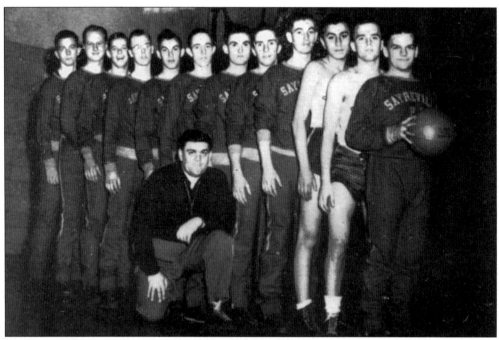

Twelve members of Sayreville High School's basketball team line up with coach Bill Colucci for this 1944 photograph. Standing, from left to right, are John Johansen, Henry Parciak, Ted Gutkowski, Mike Czok, Henry Walerzak, Homer Dill, Buddy Woods, Johnny Wortley, Chick Callahan, Ted Galepides, John Lapa, and Charles Derent.

Teachers at the Washington School gather for an informal snapshot c. 1935. They are Catherine Samsel, Helen Disbrow, Catherine Disbrow, Phyllis Eastham, Marguerite Dolan, Ella Boehm, Frances Boehm (guest), Marian Samsel, Hazel Whitehead, Elizabeth Smith, Margaret Lehman (school nurse), and Emma Arleth.

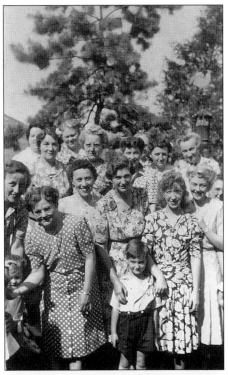

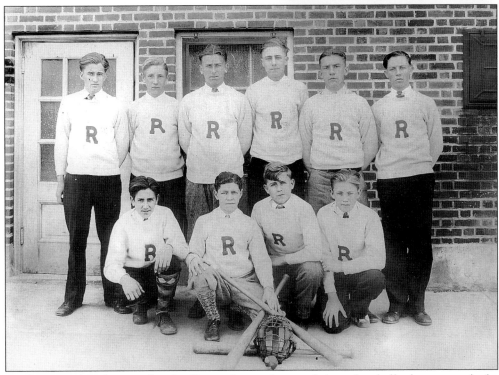

In this c. 1930 photograph, the R on the uniforms of these baseball players stands for Roosevelt School.

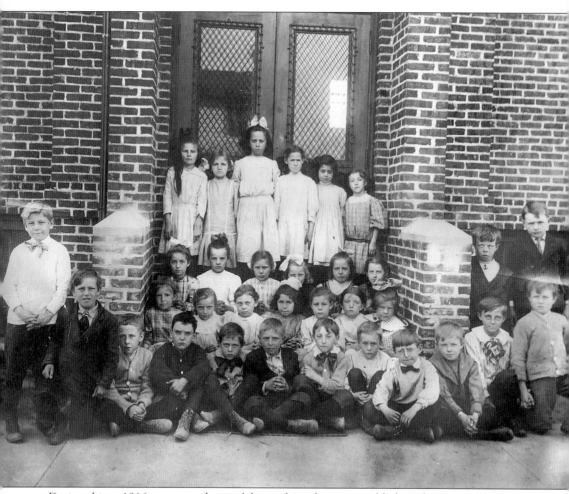

During this *c.* 1916 recess, students of the sixth grade are assembled on the steps of the Lincoln School for a class photograph.

Five
HOME OF NATIONALLY KNOWN INDUSTRIES

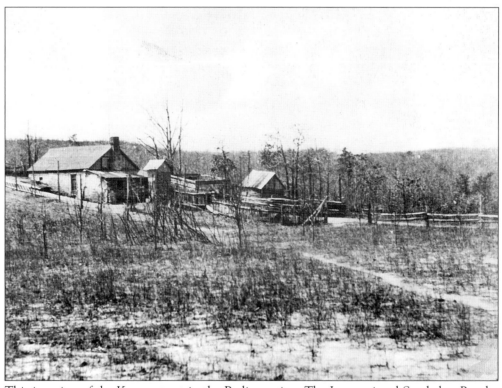

This is a view of the Keenan tract in the Parlin section. The International Smokeless Powder and Dynamite Company launched the production of gunpowder in 1898 at a pilot plant located at this site.

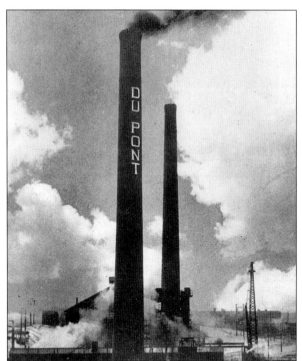

E.I. duPont de Nemours purchased the International Smokeless Powder and Chemical Company in 1903. DuPont became an important 20th-century center of industry in the growing community. The two Parlin plants, Fabrics & Finishes and Photo Products, at one time employed more than 3,000 local residents. Duco automotive paints, adhesives, solvents, plasticizers, bronze powder, x-ray, movie, and graphic arts films were produced at these two plants.

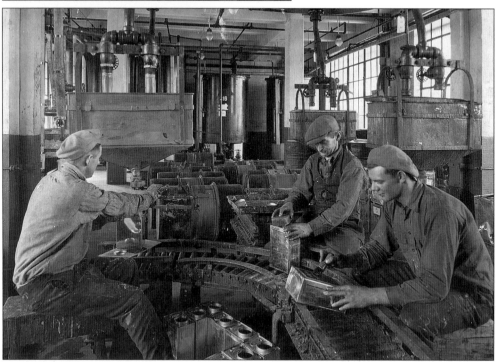

This 1920s assembly line picture shows employees filling and capping Duco paint cans at the Fabric & Finishes Division of the DuPont Company. Duco paints, developed at this location, enabled the auto manufacturers to cut finishing time from weeks to hours. Duco paints were also used on airplanes, railroad equipment, and furniture.

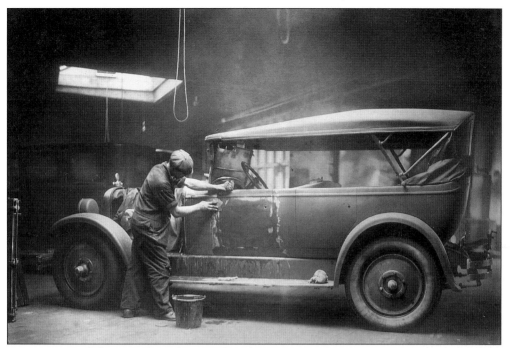

Private automobiles were brought into the plant for refinishing. This employee applies test paint on a Ford in the early 1920s.

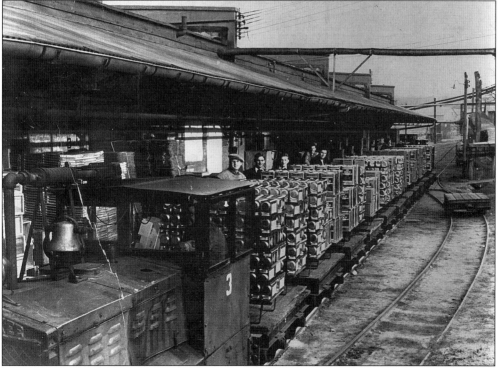

Pallets of paint cans are loaded onto a railroad car at the Fabrics & Finishes Division shipping house.

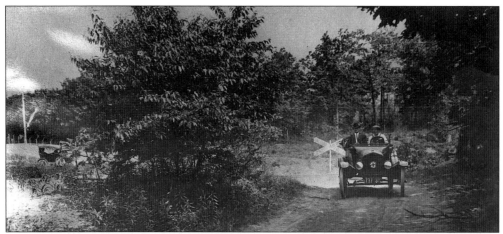

Employees drive to the DuPont bronze plant located along Cheesequake Road. From 1917 until the 1950s, the plant produced on average 50,000 pounds per month of the finest grade bronze powders. Copper and zinc were smelted, poured into forms, put under mechanical hammers, and subjected to hours of stamping. This process beat the bronze into foil-like sheets, which readily broke into small flakes and were then passed through screens to a fine powder. Bronze powder was used in gold paint, by the paper-coating industry, and in the printing trade (for the manufacture of labels).

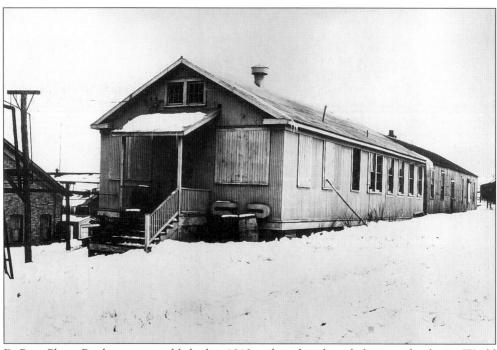

DuPont Photo Products was established in 1912 and produced smokeless powder during World War I. In 1920, the company developed and manufactured an improved motion picture film. In 1939 for this effort, the company received an Oscar from the Academy of Motion Pictures Arts and Sciences for film excellence. Expanding in the early 1950s, they developed and produced a polymer film base, which pioneered a new standard in the graphic arts industry and resulted in a superior x-ray film. Shown is one of the earliest laboratories in Parlin.

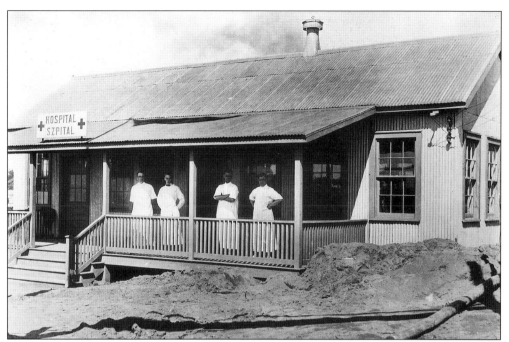

The DuPont Emergency Hospital, erected in 1916, was located between the Fabrics & Finishes and Photo Products plants. It administered not only to the employees' but also to the general public's health needs. Many township children had tonsillectomies performed here. Notice the Polish spelling of the word hospital on the sign. A new red brick hospital was built in 1926.

Raymond Witkowski, shown in his chauffeur's uniform, drove the first truckload of nitrate film from DuPont Parlin to New York City in 1929.

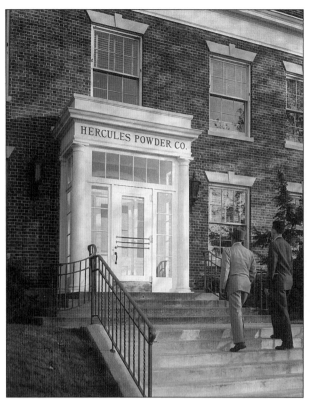

This is the entrance to the Hercules Powder Company's administration building, which was erected in 1930. Hercules was established in 1912 as an offshoot of the E.I. DuPont de Nemours Company as a result of an antitrust suit. In 1915, the Union Powder Company was purchased to increase capacity of nitrocellulose and smokeless gunpowder manufacture. After World War I, new uses were developed for nitrocellulose in the plastics, lacquer, and photograph film industries. The original company main office (*c*. 1915) is pictured below.

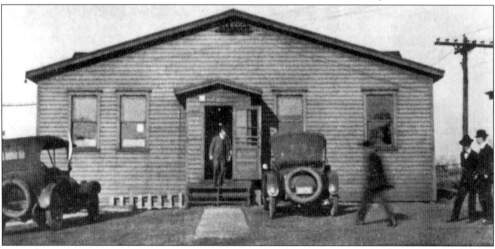

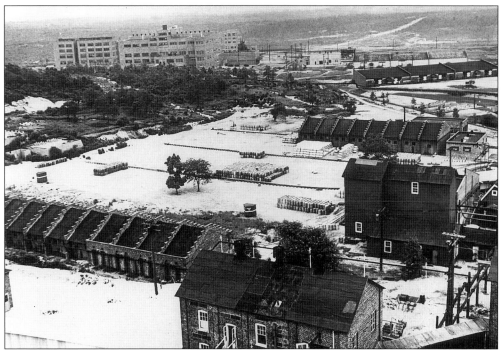

This aerial view of the Hercules Powder Company, after World War I, shows the company's storage buildings for explosive materials. The buildings were intentionally built long and low and were segregated to insure the safety of employees and the community in the event of fire or explosion. Hercules supplied munitions to the powers of Europe and the armies of Czar Nicholas of Russia.

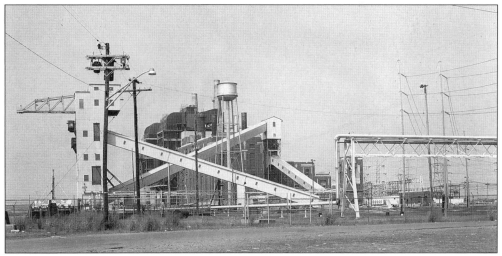

Before 1898, each Sayre & Fisher brickyard was equipped with its own steam power plant. In that year, the company built a central power station, the Sayreville Electric Light & Power Company. In 1903, it powered the first streetlights installed on Main Street. By 1926, electricity was available for homes. About that time, the utility was sold to a Chicago consortium and operated as the Jersey Central Power & Light Company.

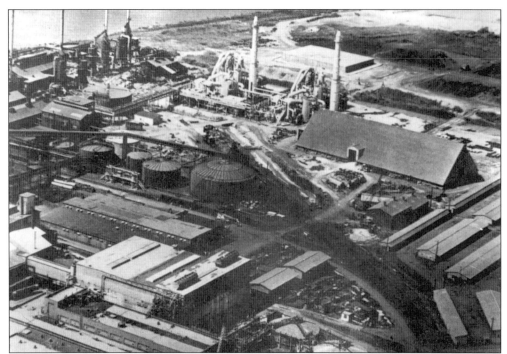

In 1933, this huge complex was built as the Titanium Pigment Division of National Lead Industries, producing titanium dioxide for the paint industry. National Lead was known as the home of Dutch Boy paints. Located at the mouth of the Raritan River in the Melrose section of the borough, the plant was situated on 63 acres of land and boasted 1,900 feet of waterfront. After 50 years, National Lead closed this facility, and the factory was dismantled.

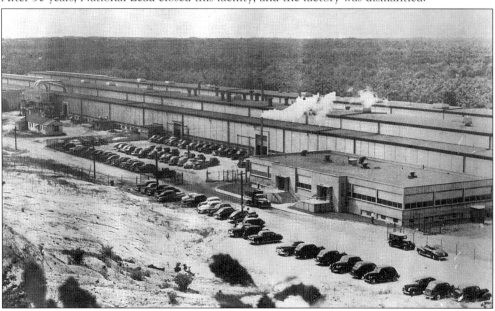

The Owens Illinois Company constructed this 20-acre building on Jernees Mill Road in 1948. Owens produced Kaylo, a fire retardant insulation and roofing material. The plant was later purchased and renovated by the Sunshine Biscuit Company.

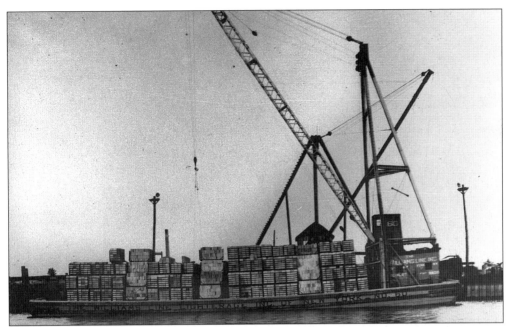

This barge on the South River was used to ship hollow tile manufactured by NATCO (National Fire Proof Company). The oversized red-faced brick was dried in a continuous tunnel kiln, the first of its type in the ceramics industry. The plant, located on Jernees Mill Road, was later sold and converted to an industrial park.

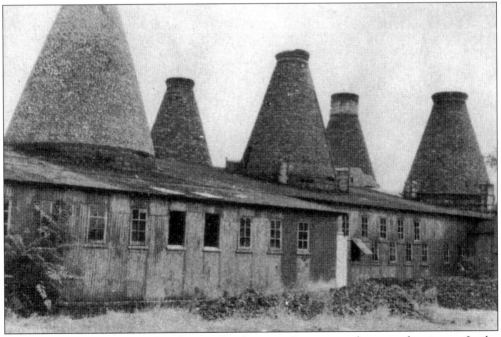

Brick kiln stacks of the Quigley Plant on Bordentown Avenue are shown in the picture. In the early 1930s, Quigley purchased the Old Bridge Enameled Brick & Tile Company from the borough, which had acquired the plant through a tax foreclosure. The Quigley Company manufactured insulating bricks and a high-temperature cement used to line steel hearths.

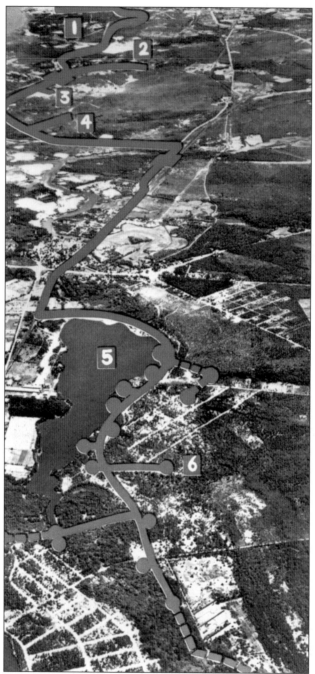

This aerial map shows the location of (1) the National Lead Company, (2) DuPont, (3 and 4) Hercules, (5) the reservoir, and (6) the Duhernal Well Field. The name Duhernal is derived from three companies—DuPont, Hercules, and National Lead. The Duhernal Water System is the culmination of a cooperative effort of these companies to obtain a dependable water supply for their operations. In 1938, a dam built across the South River helped form the one-and-a-half-mile-long Duhernal Reservoir. The 1,000-acre well field is a state game preserve and stocked by the Fish and Game Commission.

Six

PEOPLE, PLACES, AND HAPPENINGS

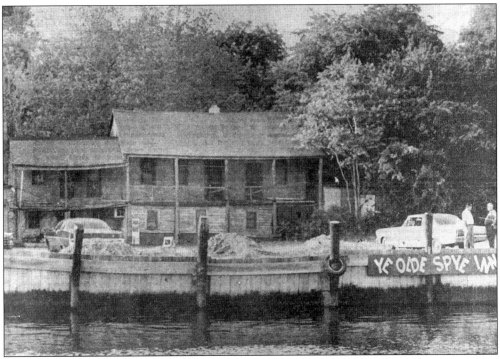

Ye Olde Spye Inn was built in 1702 as a temporary home of the Morgan family. New owners operated the house as an inn at the time of the Revolutionary War. The two-story inn on the west side of Cheesequake Creek received its name from the hanging of Abe Mussey, who was accused of passing secrets to the British. Local lore tells of Mussey haunting the old building. As the Applegate Hotel, it offered "an excellent beach for lovers of bathing and swimming." The last remaining trace of the inn vanished when fire consumed the building in 1976.

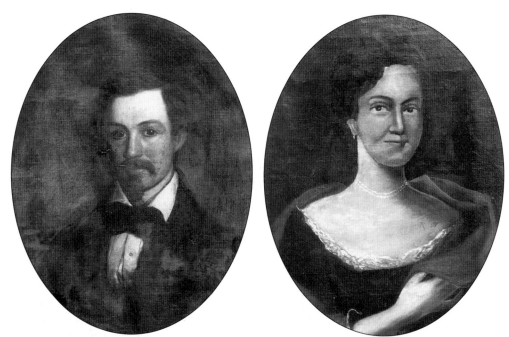

Maj. Gen. James "Jamy" Morgan Jr., the eldest son of Capt. James Morgan, served as a line officer in the Revolutionary War and later as major general in the militia. He was a representative to the General Assembly in Philadelphia, 1794–1799, and was elected to a term in the 12th congress, 1811–1813. James married Ann Van Wickle in 1805 after the death of his first wife, Catherine Van Brockle, pictured here in the late 1700s. Born in January 1757, Jamy died in November 1812. His gravestone in the family burying ground reads, "Ah stranger pass not by this stone But stop and leave a tear The friend of all, a foe to none In peace lies slumbering here."

Life was decidedly rural along Ernston Road in 1900. The rutted dirt road between the township proper and the Morgan section passed through largely undeveloped land covered with a sparse growth of oak and scrub.

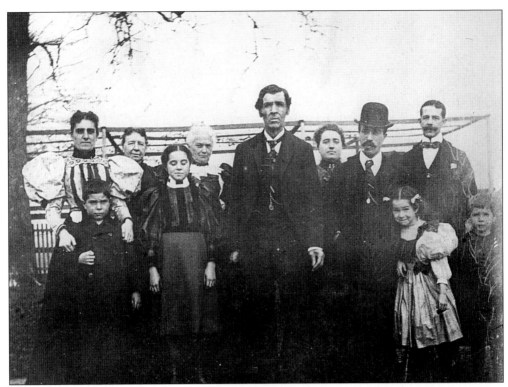

Peter Fisher (center) poses with members of the Dunlop, Furman, and Fisher families *c*. 1890.

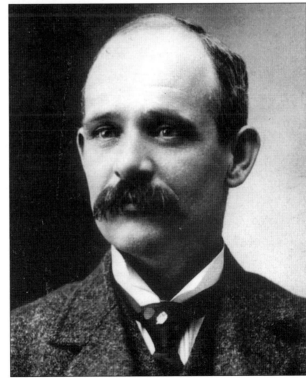

On November 4, 1919, Democrat John J. Quaid was elected Sayreville's first mayor, defeating Republican opponent Charles W. Fisher by 67 votes. A total of 917 registered voters cast their ballots.

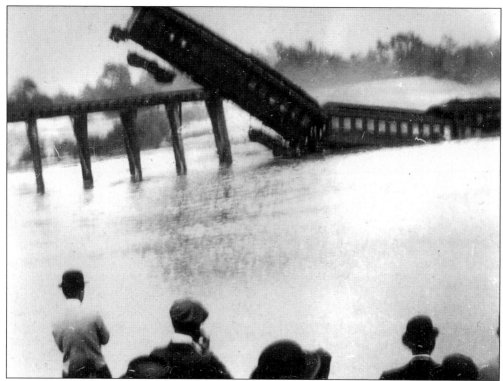

A sequence for the silent film *Juggernaut* was filmed in 1914 at Duck's Nest Pond, a local swimming hole now called Bailey Park. The Vitagraph Company of Fort Lee staged the crash, in which a locomotive and three cars (filled with mannequins) plunged off a trestle into the water.

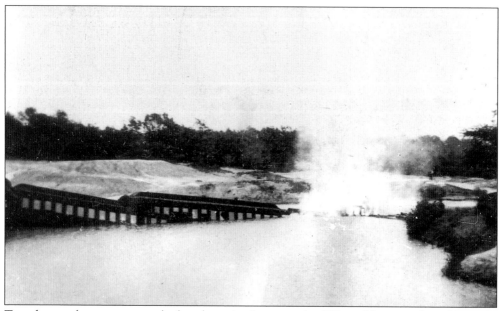

Two thousand spectators watched as the train shot over the 100-yard-long trestle at 50 m.p.h. Dynamite shattered the trestle and pitched the train into 6 to 10 feet of water.

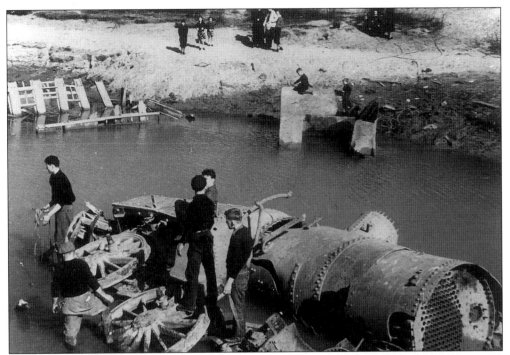

Mannequins appeared around town for several weeks, but it was not until 1938 that the wreck was salvaged for scrap. Preparation for the staged wreck cost Vitagraph $25,000.

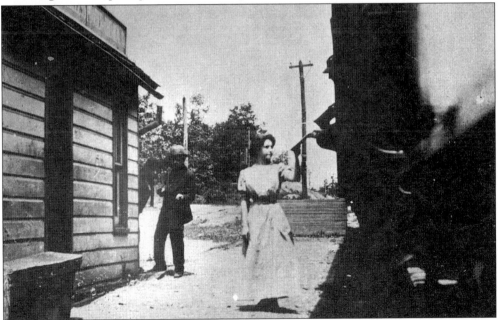

This *c.* 1910 photograph is believed to have been taken during the filming of an episode of *The Perils of Pauline* at the former Raritan River Railroad station in Parlin. The station played a role in many filmed train wrecks. Silent film actress Pearl White played the heroine in the popular adventure serial produced by the French-owned Pathe-Frers of Jersey City. Pathe is best known for its newsreels featuring a crowing rooster at the beginning of each issue.

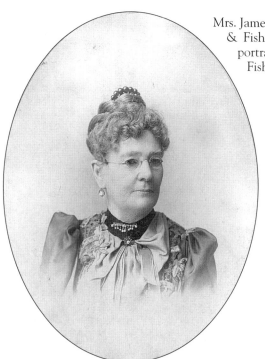

Mrs. James R. Sayre, wife of the cofounder of the Sayre & Fisher Company, posed for this elegant studio portrait in the late 1800s. The Sayres, unlike the Fishers, did not live in Sayreville.

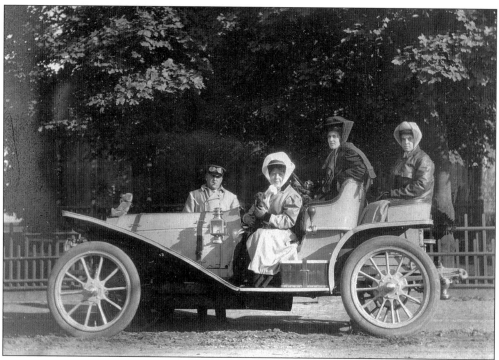

Preparing for a Sunday afternoon outing at the beginning of the 20th century, this unidentified group is presumably made up of members of the Fisher family. Influenced by the early days of motoring, the ladies wear protective gloves and hats tied on their heads with a scarf. A teddy bear is mounted on the hood of the touring car.

This handsome winter scene comes from the pages of a Fisher family photograph album of the late 1800s. Note the wide-brimmed chapeaux the driver is wearing. The inscription on the back of this photograph reads: "What do you think of your Jack and Taffie by your side? Snow, beautiful snow. I can almost hear the sleigh bells".

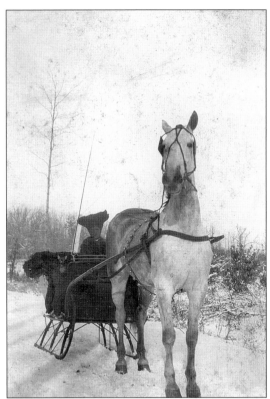

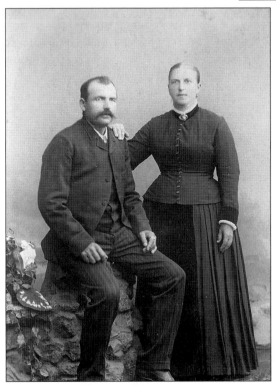

Frederick and Marie Muschick, newly arrived in America, pose for this portrait, typical of those taken to send to family back home.

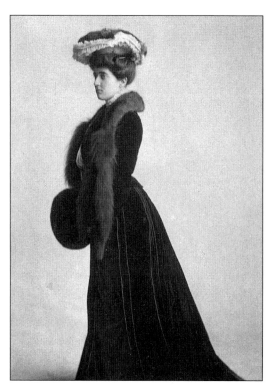

Josephine Fisher Lockhart, stylishly dressed in this self-portrait, was the first wife of Edwin Lockhart.

An unidentified young boy is shown standing on a wicker settee. Elaborate backgrounds and props were a studio vogue in the late 1800s. The large bow the boy is wearing as part of this formal attire seems a little extravagant.

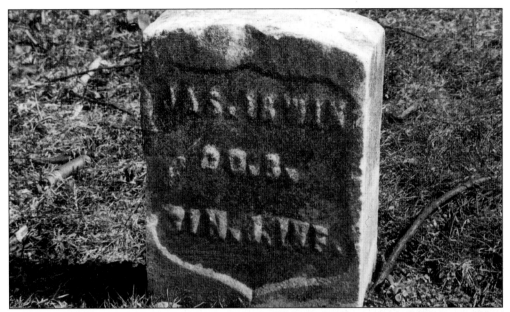

Three veterans of the Civil War are buried in Old Calvary Cemetery behind Our Lady of Victories Church. They are Patrick Dolan, Company A, 28th New Jersey Regiment; James Irwin, Company B, 31st New Jersey Volunteers; and Fred Keenan, who served with a New York unit. This is an early military marker for James Irwin. Two men of the Van Deventer line also fought in the war, and George Smith served as a drummer boy.

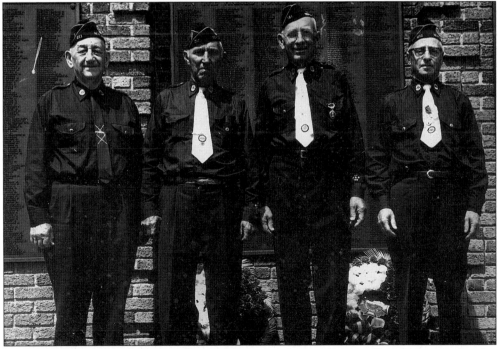

Four World War I veterans, members of American Legion Lenape Post 211, pose for this photograph following a patriotic parade in the late 1940s. From left to right are Bill Unkel, Milton Yetman, Ted Unkel, and Ben Fritz.

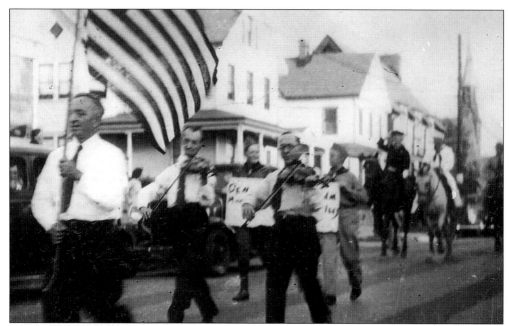

Violinists John Strek (right), Paul Mazur, and flag bearer Ben Modzelewski re-create their impromptu V-E Day celebration at the official Welcome Home Parade. Fulfilling a promise made earlier, they marched up Main Street playing their violins on the announcement that the war in Europe had ended on May 8, 1945.

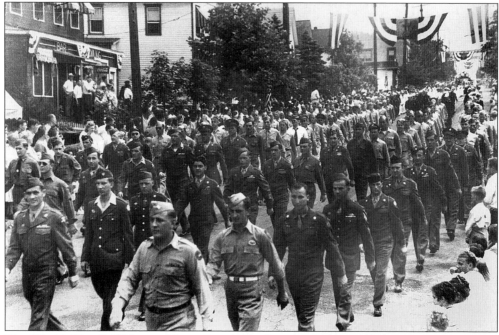

The World War II Welcome Home Parade in August 1946 was the largest in Sayreville's history. It included many veteran and military groups, local bands, and floats. The parade is shown marching up Main Street to the reviewing stand and post-parade ceremonies at the War Memorial Monument.

Maj. Stanley J. Pytel, U.S. Air Force, is shown in his flight suit and gear with his F-86 Sabre Jet fighter plane in the background. Pytel made international headlines when he and two other pilots broke through the sound barrier on May 22, 1953, at Bentwaters Air Base, England, in a special demonstration for the Duke of Edinburgh, husband of Queen Elizabeth. After 20 years in the Air Force and over 4,000 hours in fighter planes, the major and his family retired to Washington State.

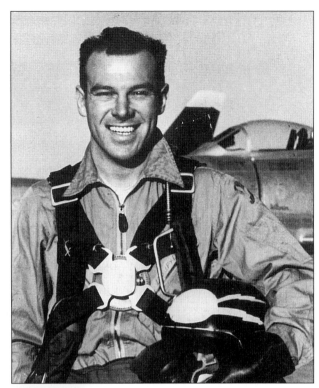

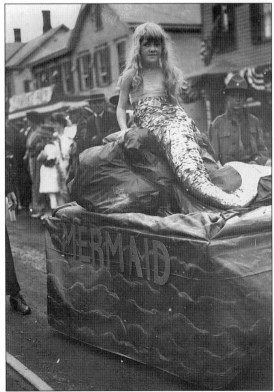

The annual baby parade down Main Street was a popular spring event and featured creative costumes and floats. In this c. 1925 photograph, pretty Evelyn Mazur rides a float dressed as a mermaid. Evelyn became a teacher in Sayreville.

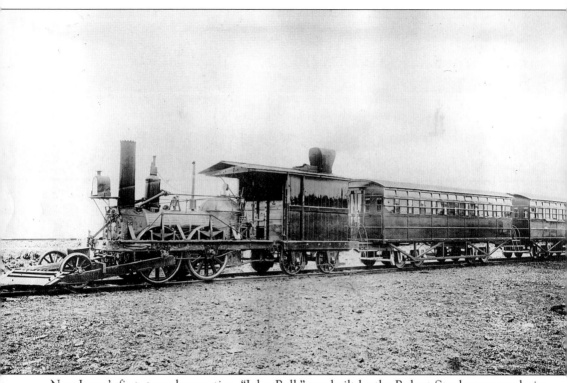

New Jersey's first steam locomotive, "John Bull," was built by the Robert Stephensen works in Newcastle, England, in 1831 for the Camden & Amboy Railroad. Isaac Dripps assembled the engine without the aid of blueprints. Late in 1833, "John Bull" began regular passenger and freight service to South Amboy on Camden & Amboy rails that ran through Sayreville along Bordentown Avenue. The track still runs through Sayreville, Spotswood, and Jamesburg. "John Bull" was retired in 1865 and placed in the Museum of American History at the Smithsonian Institution in Washington, D.C. The original "John Bull" is the oldest intact locomotive surviving in America. The Camden & Amboy Railroad was absorbed by the Pennsylvania Railroad system.

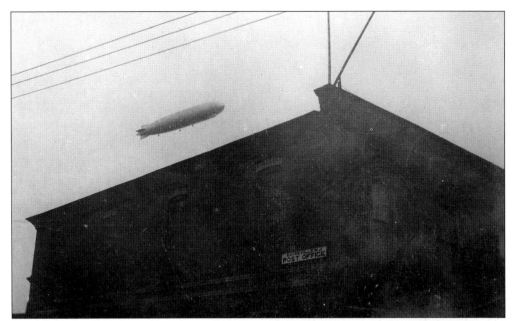

The Graf Zeppelin bound for the Naval Air Station at Lakehurst on its maiden flight flies over the old post office located at River Road on October 15, 1928. In 1912, the 800-foot, 50-passenger German airship flew around the world in 21 days and 8 hours. No other dirigible has ever completely circled the world.

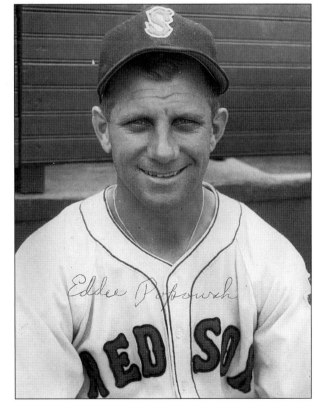

Edward "Buddy" Popowski, pictured in the 1940s, has played, coached, and managed major and minor league baseball for 64 years. In 20 years of managing in the minors, he won four pennants and five second-place finishes. Eddie was named Boston Red Sox coach/interim manager in 1967. Buddy moves south each year, where he is an infield instructor for the Red Sox in the Florida Instructional League.

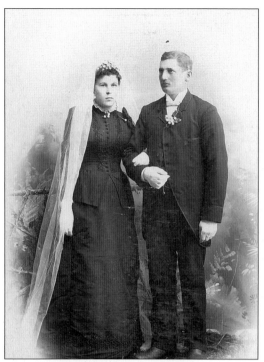

For much of the 19th century, brides wore a formal dress of any color. Headpieces and boutonnieres were also typical of the period. The white wedding, a fashion innovation of Queen Victoria, became popular in the early 1900s. Unfortunately, the identity of this attractive couple has been lost in time.

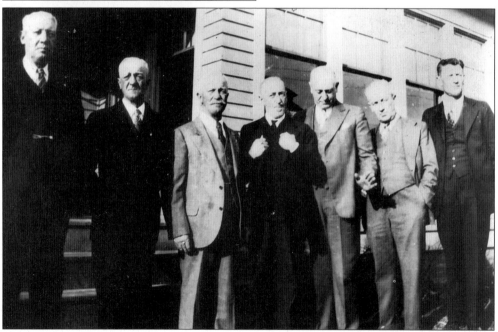

Seven Letts brothers, descendants of one of Sayreville's earliest settlers, pose in the late 1890s. William Letts, a weaver, arrived in America in 1665. From 1711 to 1889, the Letts family acquired considerable land at the Roundabout and between Main Street and Washington Road along Pulaski Avenue (then Kathryn Street). They became well-known potters of Middlesex County. Five men of the Letts line fought in the Revolutionary War. Pictured, from left to right, are James, twins Richard and George, Robert, John, Edwin, and William.

A lifelong resident of the borough, Anita Skwiat Roginski (1903–1987) was 19 years old when this fetching portrait was taken. She wears a long string of pearls, a signature fashion of the flapper era.

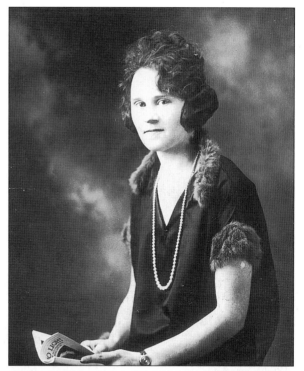

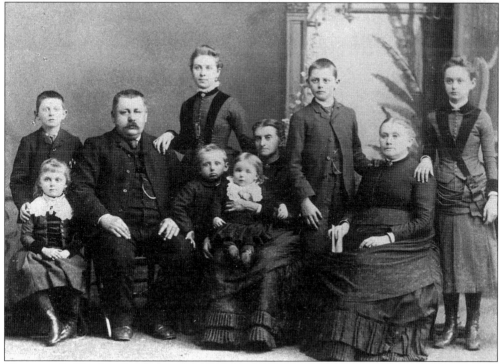

The extended Boehm family is gathered for a portrait taken *c.* 1898. They are, from left to right, Kathleen, Chris, "Grandpop," Mrs. Hannah Major, Henry, Casper, Grandma, George Boehm, Mrs. Kuhn (Rutman) Sweeney, and Aunt Elizabeth Heilman.

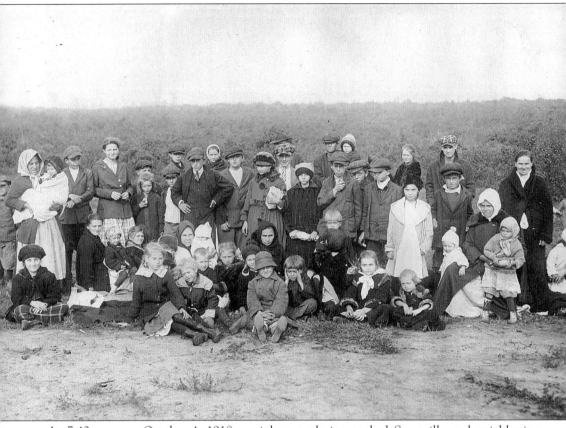

At 7:40 p.m. on October 4, 1918, a violent explosion rocked Sayreville and neighboring communities, uprooting trees, overturning poles, tearing homes from their foundations, and sending artillery shells around a one-and-a-quarter-mile radius from its origin near present-day Eisenhower School on Ernston Road. Successive explosions terrified the community for three days. The concussion of the most destructive blast on Saturday morning shook buildings 50 miles away across Raritan Bay, and New York City shut down its subway system. The disaster happened after the U.S. government had contracted the T.A. Gillespie Company to construct and operate a munitions complex on eight square miles of government property in Sayreville. The Morgan Depot, as it was known, became the largest source of ammunition in World War I, employing 6,500 workers and producing 32,000 shells a day. The shell-loading plant was leveled in the explosions, 62,000 people were forced to evacuate their homes, between 100 and 200 people died, and hundreds more were injured. Approximately 12 million pounds of powder and 200,000 shells detonated. The plant was abandoned shortly after the armistice ending World War I was signed. The cause of the explosion was never officially determined. This picture shows a group of refugees from the scene of the explosion. The photograph is attributed to Underwood & Underwood photographs, 1918.

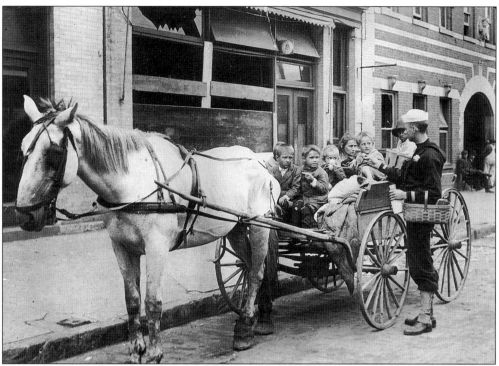

Refugees, their homes destroyed, are fed by a member of the naval reserve.

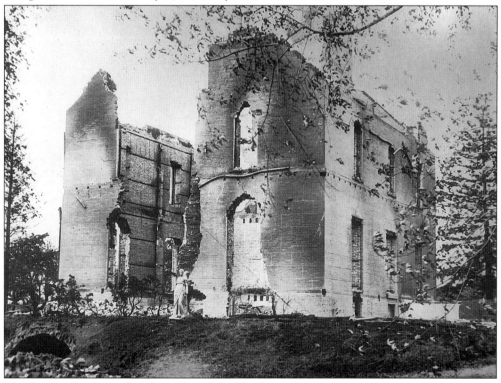

This home of a plant official was demolished by flying shrapnel.

Arnold (left) and Charles—the sons of Charles and Katherine Meyer Engelhardt—were handsomely dressed for this *c.* 1900 portrait. Little boys wore dresses in that era, and fashion dictated elaborate blouses and boots for young boys. Arnold died from the measles at age three. Charles succumbed to scarlet fever shortly after his fifth birthday.

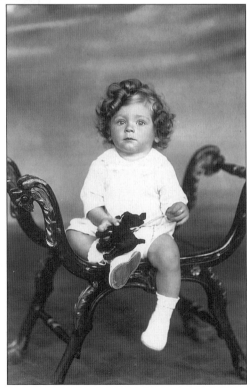

Young Robert Puchala was not intimidated by the camera when sitting for this 1940s photograph.

Olivia Kupsch Miller, who died September 26, 1995, at age 105, gave generously of her time and talent. She was the organist at Our Lady of Victories Church, directed the children's choir, and staged many parish minstrel shows. Miller was an accomplished pianist and played piano accompaniment at the Liberty Theatre during the era of silent films. She also rehearsed with and accompanied performers who presented their acts during weekend vaudeville shows at the Liberty Theatre.

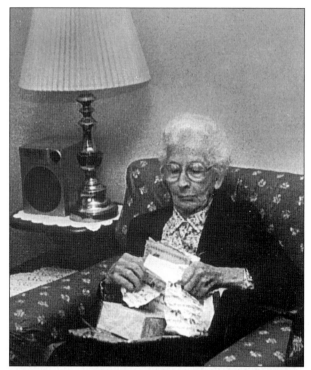

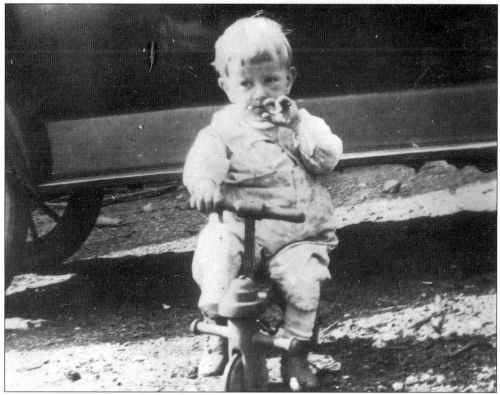

This little fellow did not know he was on camera. Shown *c.* 1910, he is identified as Dick Smith.

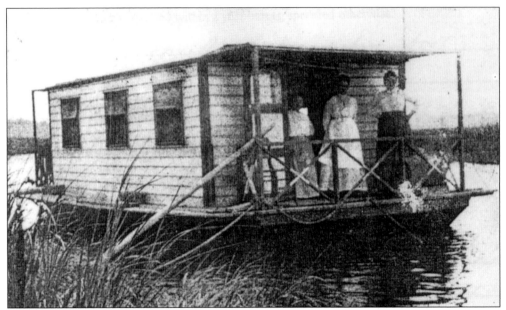

Emma Brehme and friends, photographed c. 1840, enjoy a weekend on Brehme's houseboat on the Morgan Creek. Brehme and her husband, Herman, spent many weekends and summers at the Morgan Beach, settling there permanently in 1913. In 1915, Emma converted her home on Route 35 into a seafood restaurant. They sold the property in 1937. It then became Kozy Bar and Grill and subsequently the Club Bene.

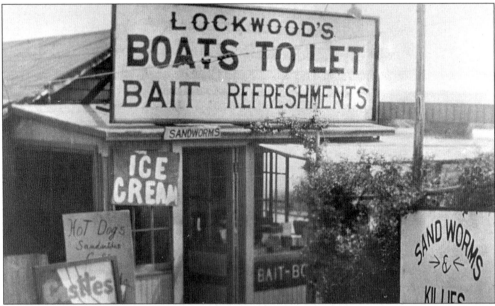

William Lockwood Sr. owned and operated a boat rental in 1930 on Old Spye Road, which borders Cheesequake Creek. The area now is contained within the Lockwood Boat Works Marina. This section of Sayreville has changed since the days of the Revolutionary War and rumrunners. Today it is a tranquil site of marinas and waterways flowing into Raritan Bay. Cheesequake (Morgan) Creek is named for a family of Lenni Lenape who once lived along the shorefront.

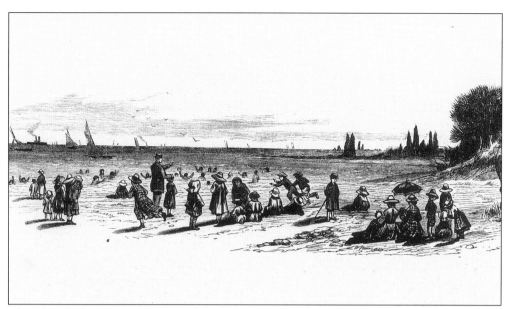

This sketch depicts Morgan Beach overlooking Raritan Bay. Here, the West Side Relief Association ran a summer mission for disadvantaged women and children from New York City's West Side tenements. The association paid $1 to send a child for a week's stay at the seaside sanitarium; the expense for a woman was $3. (From Frank Leslie's *Illustrated Newspaper*, September 2, 1876.)

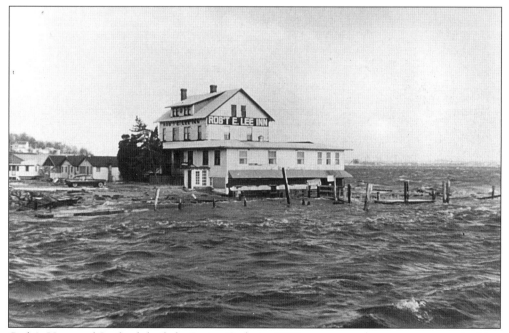

Cady's House of Seafood, built by James Cady in 1926, was a popular restaurant overlooking the Raritan Bay and Morgan Creek. Later known as the Robert E. Lee, it was accessible to both pleasure boats and travelers on Route 35 in Morgan. This 60-year-old landmark was destroyed in a spectacular early morning fire in the 1980s.

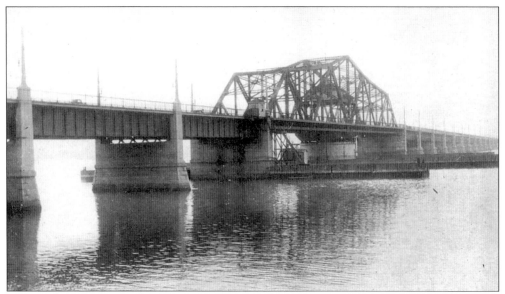

The mechanical swing Victory Bridge crossing the Raritan River was completed in 1926. County Bridge, its predecessor (shown below), opened June 19, 1906, and was the first wooden drawbridge that linked Sayreville and Perth Amboy.

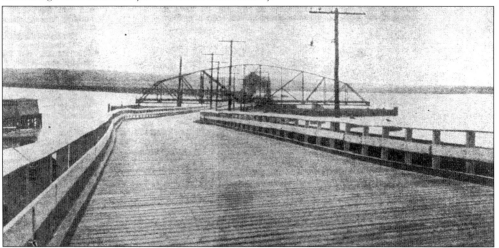

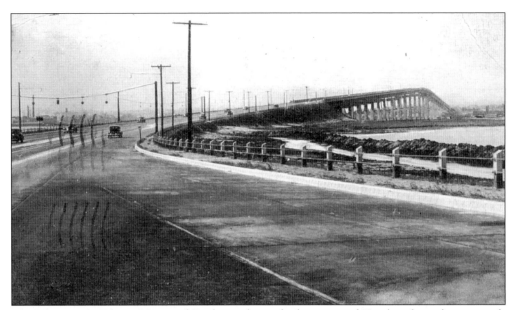

The Thomas A. Edison Memorial Bridge is shown looking toward Keasbey from the approach in Sayreville. The bridge, which spans the Raritan River, opened in 1940.

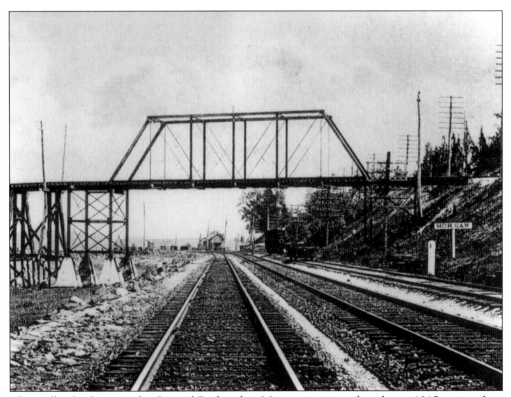

The trolley bridge over the Central Railroad in Morgan is pictured in this c. 1915 postcard.

Industrialization in the growing community created a demand for new trades. Pictured c. 1925 in coveralls is the pipe fitters crew of DuPont's Fabric & Finishes Division. They are, from left to right, as follows: (front row) S. Schultz, E. Bissett, J. Lehman, C. Sylvester, and H. Menzler; (back row) G. Rutan, J. Smullen, P. Check, W. Schwarz, L. Hoffman, and C. Boehm.

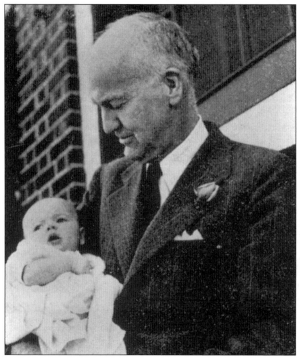

Samuel D. Hinton, M.D., a graduate of John Hopkins University, practiced as a family physician for the community at large and at the Parlin DuPont hospital from 1927 to 1947, when Dr. and Mrs. Hinton retired to their home in Georgia. Here, "Doc" holds his baby daughter, Alice Ann.

Self-employed painter, wallpaper hanger, carpenter, and mason Louise M. Snyder was a hometown institution. At 78, she was forced to retire because of a back injury. Louise and her husband, Arthur, were instrumental in the building of the Presbyterian church. To help raise money for the new church, she pledged to bake 100 loaves of bread each Friday and donate the proceeds to the church. Louise died in 1998 at age 92.

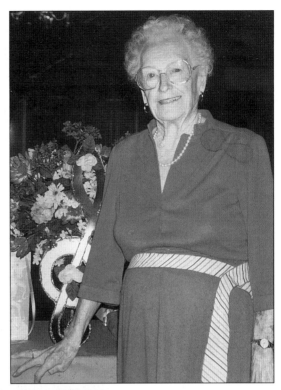

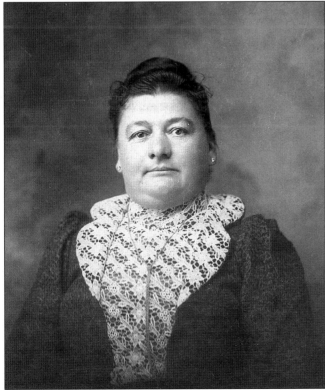

Mrs. Louisa Feihle, shown c. 1890, was the wife of Abraham Feihle, the township's first tax assessor. She devoted herself to the profession of midwifery at a time when most babies were born at home. Louisa is buried in the family plot adjoining Our Lady of Victories Church.

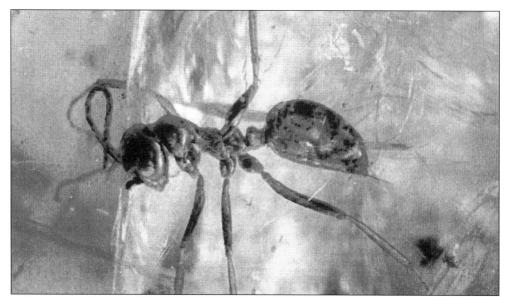

Hundreds of fossilized specimens have been found trapped in amber combed from an old Crossman Company clay pit. The site is considered one of the most important paleoecological sites in North America. The pit has yielded amber that preserved ancient ants, the oldest mosquito, a cluster of flowers, and the feather of a terrestrial bird. These specimens date back to between 90 and 94 million years, when the region was tropical and the site of a cedar bog. Sayreville amber is on display at the American Museum of Natural History in New York City and the New Jersey State Museum in Trenton. This is a primitive ant. (Photograph by Frank M. Carpenter, Harvard Museum collection.)

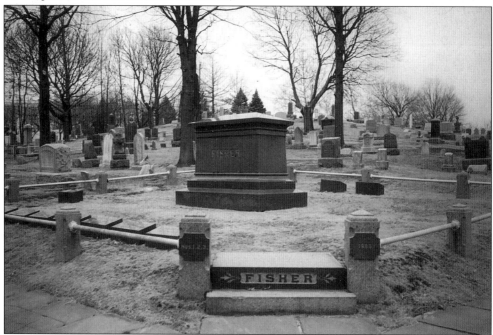

About 14 members of the Fisher family lie at rest on a knoll overlooking the Raritan River in Washington Monumental Cemetery in neighboring South River.

Seven

SERVING THE PEOPLE AND THE COMMUNITY

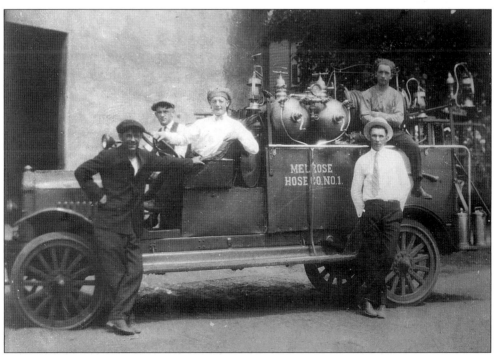

The Melrose and Morgan sections of town formed fire companies in 1922 and 1927. This c. 1922 photograph shows the Melrose Hose Company's Day Elder Truck. From left to right are the following: (front row, standing) Frank Kosh and Stanley Wisniewski; (back row, sitting) Ben Maliszewski, Andrew Kosmowski, and Dan Palmer.

Henry Boyler is identified as the patrolman on the right in this *c.* 1920 photograph.

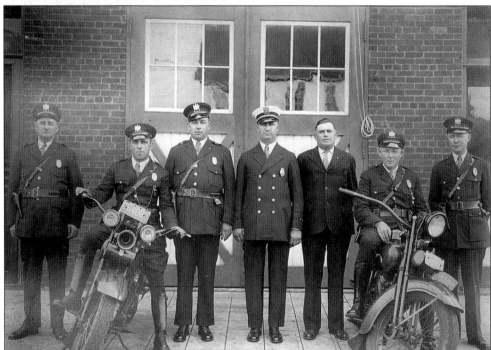

The Sayreville Police Department was created in 1920 with six full-time uniformed members. Earlier, the township was served by two constables who patrolled on foot. Shown in 1930 are, from left to right, Chris Keegan, John Wisniewski, Harry Olsen, Chief George Gross, Councilman Edward Englehardt, Jacob Freschnecht, and John Rhatican.

George Gross was appointed the first chief of police and served the borough for more than 30 years.

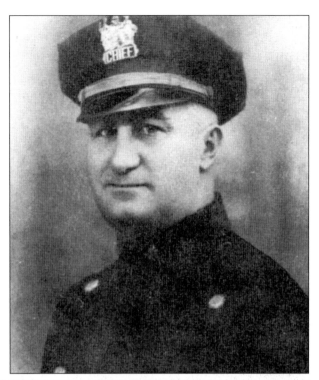

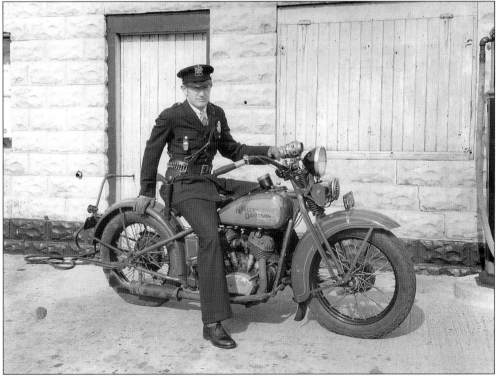

Neil Chevalier, a patrolman of the Sayreville motorcycle squad, is shown on the Harley Davidson c. 1940.

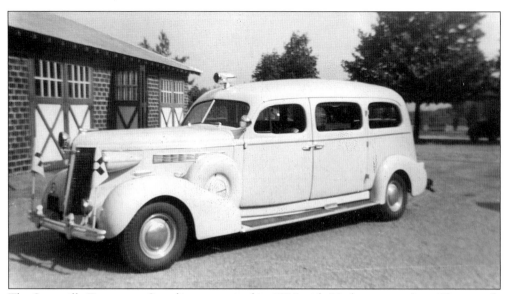

The Sayreville Emergency Squad was organized in 1936 with 38 charter members. The squad's first ambulance was a pre-owned hearse modified with red flashing lights. Later, a used bread delivery truck was converted into a crash/rescue vehicle.

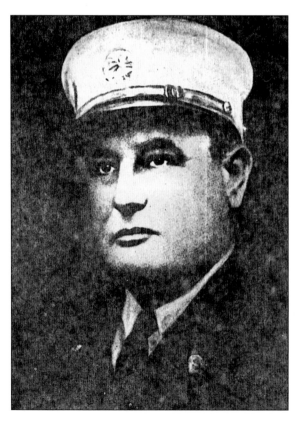

Noel Bissett was appointed the first fire chief in 1916.

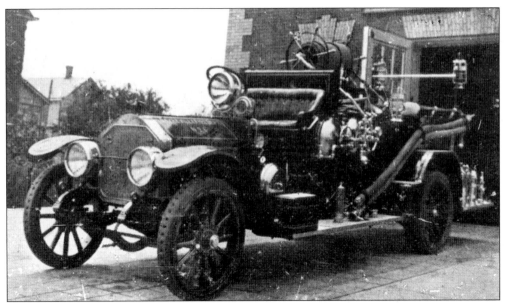

Sayreville Engine Company No. 1 was chartered in 1919 with a membership of about 50 volunteers. The first piece of fire fighting equipment, shown here, was an American LaFrance pumping engine, which had been purchased in 1916 for $4,950. It served the municipality for 25 years. The company was originally housed on the first floor of the town hall, adjacent to the present borough hall, and remained there until a new firehouse on MacArthur Avenue was dedicated.

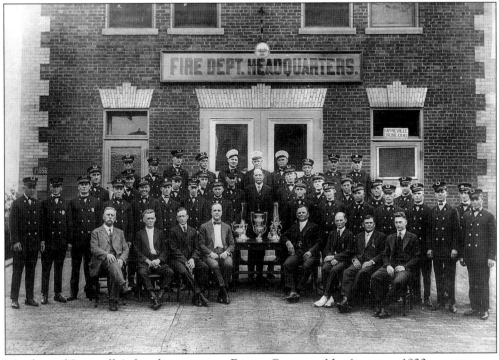

Members of Sayreville's first fire company, Engine Company No. 1, pose c. 1920.

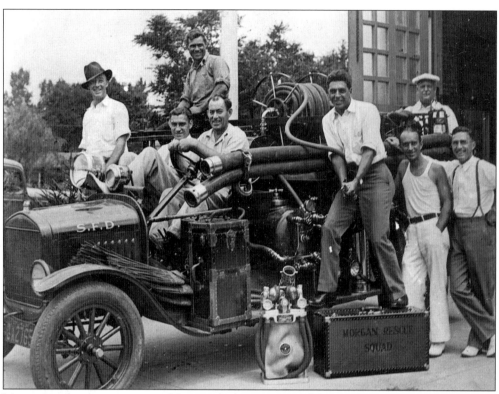

Morgan's volunteers are pictured here with their 1926 Ford fire truck.

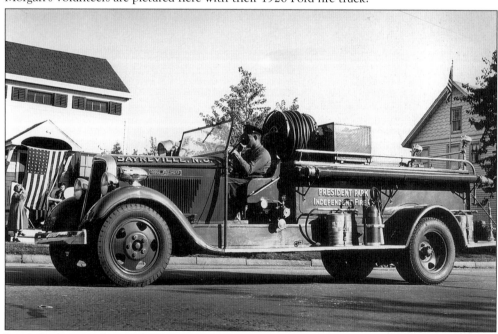

In 1947, the President Park section petitioned for a fourth fire company, which was organized as the President Park Independent Fire Company. Here, in 1952, is the company's Dodge Brothers truck is on parade in neighboring Keyport.

The people of Sayreville have volunteered their time and energy to many organizations. Pictured is the charter of the local Lions Club (1936), still active today.

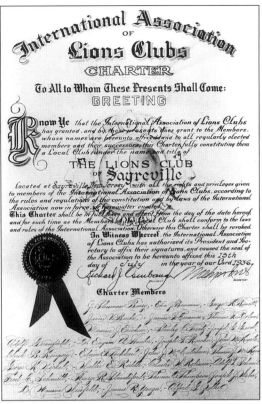

The Sayreville Community House was located at 113 Main Street adjacent to the building that once housed the town cinema. Today the house is a private residence. A Red Cross banner can be seen in the upper window in this *c.* 1917 image.

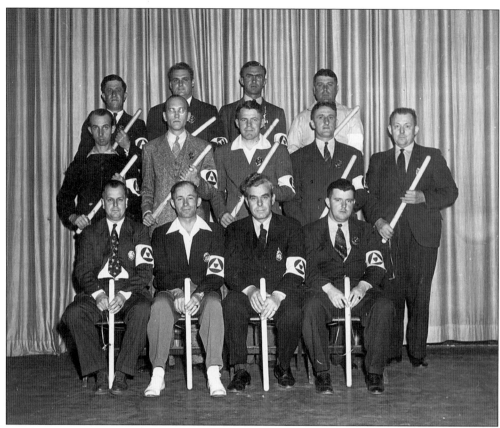

Local Civilian Defense (a corps of volunteers organized to help in time of war) formed *c*. 1940. Air-raid wardens are shown here wearing official arm bands and holding night sticks. Known to be in the photograph are John Zollinger, James Creamer, Bill McCutcheon, Jake Frischnecht, Andy Thompson, and Andy Clausen.

Eight

PASTIMES AND GOOD TIMES

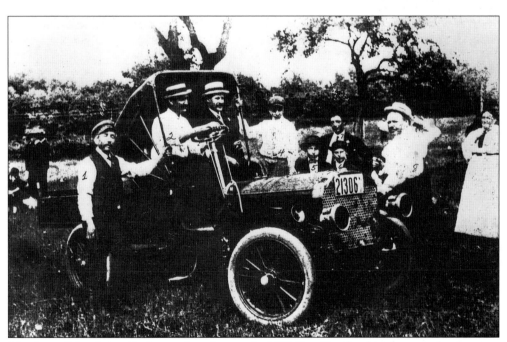

Members of the Arion Society gathered around a 1906 Rambler for this photograph taken at a 1911 outing. Shown from left to right are Ignatius Baumann, Ignatius Meyers, Charles Engelhardt, Alfred, Edwin, and John Baumann, William Fehrle, ? Yeager, and Christine Litz.

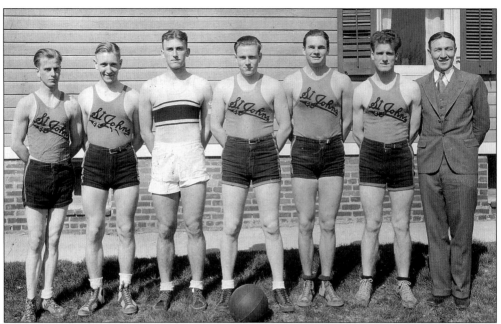

The St. John's Presbyterian Church basketball team of the 1920s poses for the camera. From left to right are Eugene Bright, Earl Icker, Walter Shinn, Dewitt Rush, Rudy Zeller, Robert Armstrong, and David Zeh.

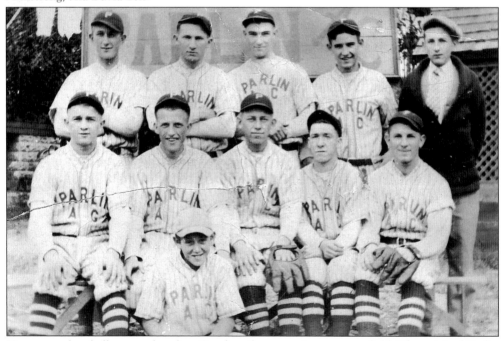

Hometown baseball teams played on Sunday afternoons in any open field. The original Parlin Athletic Club nine, organized c. 1920, are pictured, from left to right, as follows: (front row) bat boy Henry Werner; (middle row) John Pesch, Andy Kurtz, Frank Popowski, Jim Bloodgood, and John Jock; (back row) Joe and Phil Kurtz, Mike Dustal, John Paprota, and manager Zigmond Gawron.

Neighborhood boys formed sandlot baseball teams in the early years. This c. 1935 picture shows the Broadway Boys Club. From left to right are Ted Unkel, Joseph Liszka, Walter Habiak, and Charles Tripisovsky. Edward Buddy Clark is at bat and Richard Litz is catching.

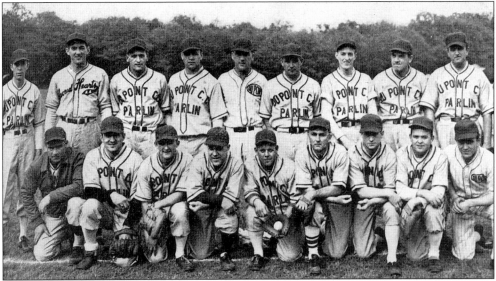

Baseball was revived as a pastime after World War II. By the spring of 1946, "play ball!" was heard at Burke's Park for the first time since 1941. The DuPont Community baseball team opened its postwar season with a hotly contested 6-4 win over Hercules. Team members shown in this photograph are, from left to right, the following: (front row) Ziolkowski, Mazurowski, Smith, Pudney, E.Popowski, Kwiatkowski, McCarthy, Lynch, and Hager; (back row) manager A. Popowski, Kukulski, Shinn, Sumoski, Bara, Soroka, Salmon, Ryan, Rundeski, and assistant manager Kuc.

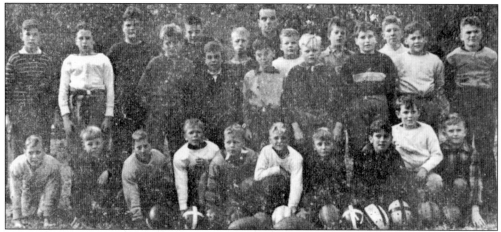

Sponsored by DuPont, Hercules, and the DuPont Film Plant, this Parlin Boys Club football team of 10- and 14-year-olds compiled an enviable 6-1-1 record. Members of the squad pictured are, from left to right, as follows: (front row) Pick Dill, Skip Kingery, Gus Dill, Billy Hockenjos, Dieble Warden, Mitzi Helgeson, Les Holthausen, Francis Homan, Howy Buchanan, and Paul Emmons; (middle row) ? Kelly, "Bottles" Newman, Ed Homan, Mike Lynch, Paul Lasko, Doug Linden, Bill Holzworth, Mop Mayer, and Mal Check; (back row) George Lowry, Dick Pringle, Jack Christfield, William Weis, Bill Burke, John Baist, and Yock Baumann.

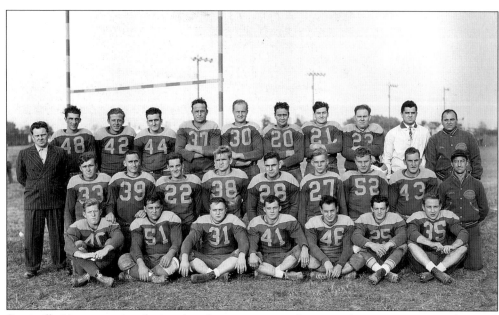

Sayreville Vets, a semiprofessional gridiron team, was determined to gain a spot in the 1947 New Jersey league playoffs. Players, confident of victory, posed for the camera before an important tussle with the Carteret Alumni.

120

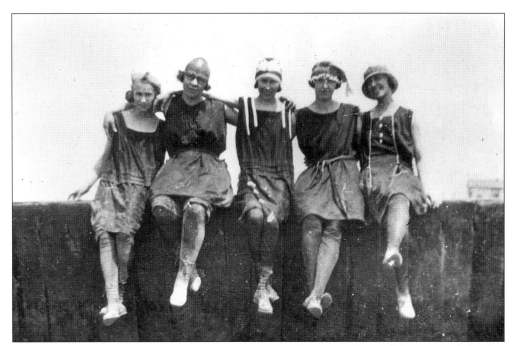

With the Raritan Bay in the background, these friends are enjoying a day at Morgan Beach. Their turn-of-the-century bathing costumes are of a light fabric, loose fitting, dark in color, and accessorized by a stylish cap. Neither the suit nor cap was to get wet.

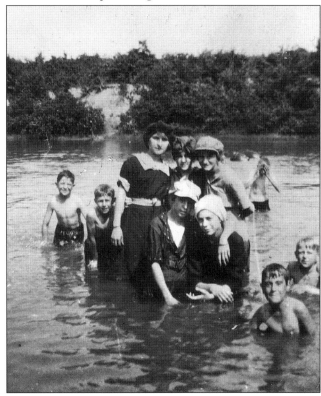

Young swimmers mug for the camera at Majors Pond. Once a clay pit, the pond is named for Anna Major, who spent summer afternoons supervising youngsters playing in the sand and cool water. Majors Pond is north of Washington Road and surrounded by Patton Drive, McCutcheon Avenue, Karcher, and Dolan Streets. In this c. 1917 photograph, Rose Uszczak is in the front, wearing a dark outfit and a white turban.

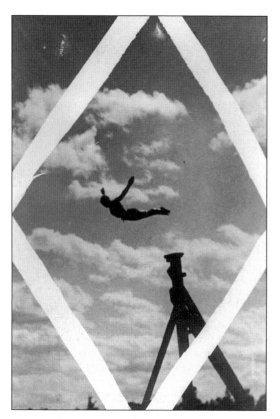

This attractive photograph, taken c. 1940, shows LaVern Clark in a swan dive from the platform of a tower over Duck's Nest Pond. Clark served as the town's first female lifeguard and was one of the first airline stewardesses in the east.

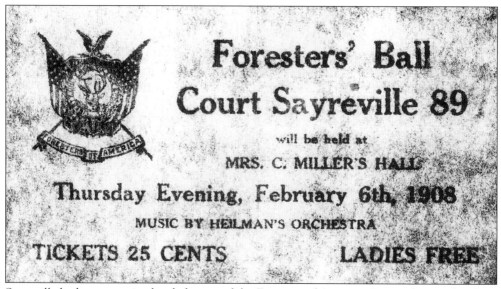

Sayreville had a very active local chapter of the Foresters of America. Pictured is a ticket from the 1908 annual ball featuring the local well-known Heilman Orchestra.

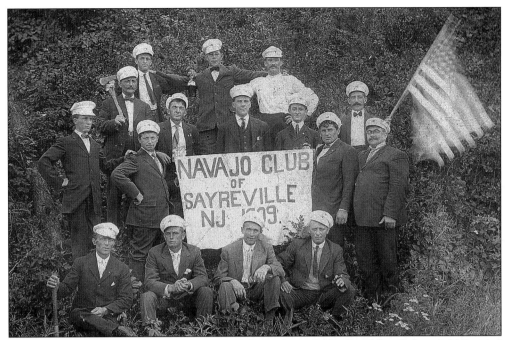

Members of the Navajo Club in 1909 are as follows: (seated, third and fourth from left) Joe and Richard Meyer; (second row, left) Charles Engelhardt; (third row, holding flag) Ignatz Meyer; (fourth row, wearing white shirt) John Engelhardt.

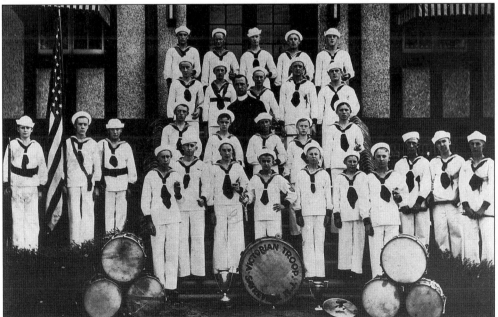

Members of the Victorian Troop Fife and Drum Corps are assembled on the steps of Victorian Hall *c.* 1920 with their mentor, Rev. Francis A. "Mack" McCloskey. Many their names are familiar: Chevalier, Weck, Sugrue, Engelhardt, Shuler, Nielson, McCutcheon, Lynch, Fortenbacker, Fritz, Letts, Hartman, Lochs, Guilfoyle, Freeman, Kupsch, Wagner, Smith, Hockenjos, Bailey, Johnson, Burkshot, and Karwatt.

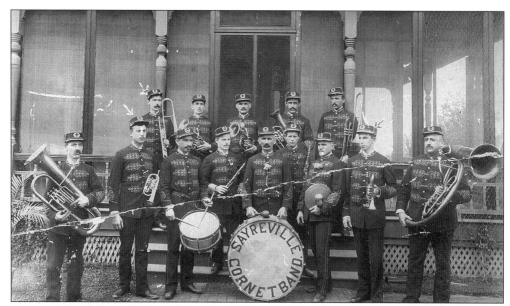

A smartly attired Sayreville Cornet Band played at many patriotic functions. Organized in 1895, it was active until 1920. All but two of the musicians pictured here sport mustaches. Shown from left to right are the following: (front row) John Haag, John Feninauf, Adolph Auer, Ignaz Meir, Fred Heilman, Albert Weck, John Roth, and ? Rupp; (back row) Henry Arleth, John Fritz, Edward Weck, Frank Doeler, and unidentified.

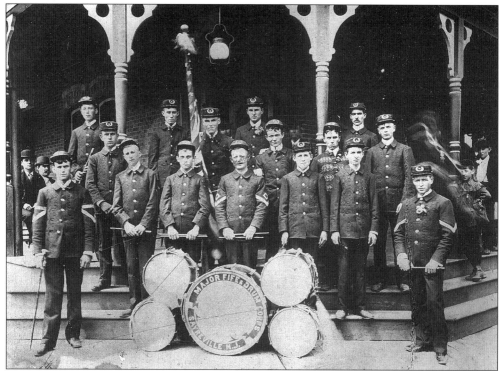

This 16-member Major Fife and Drum Corps of Sayreville provided a spirited marching beat for many parades up Main Street. This photograph dates from c. 1920.

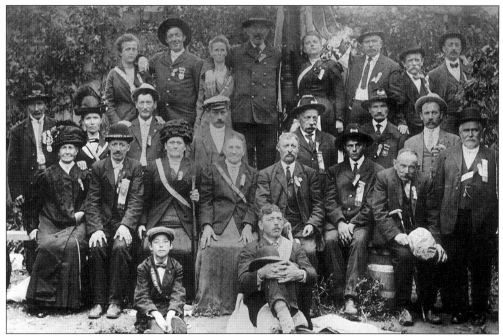

The Arion Society was one composed of members of the German-American community. Members gathered for this c. 1898 photograph. Though appearing somber, this was a fun group, as evidenced by the sashes of the two ladies declaring, "Don't Get My Goat" and "Don't Monkey With Me Kid." Note the kegs on either end of the photograph.

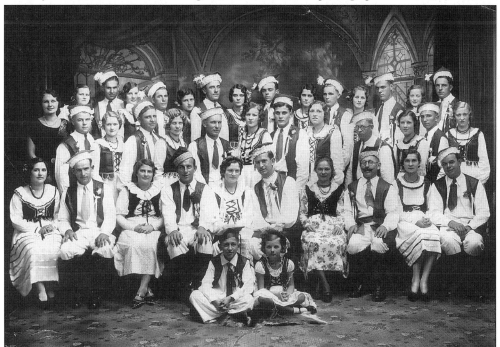

Parishioners of St. Stanislaus Kostka church dressed in traditional Polish costumes for an early 1930s presentation of *Polskie Wesele* (Polish Wedding).

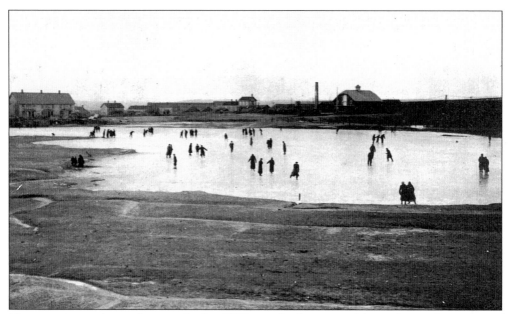

Skaters enjoy a winter afternoon in the 1920s on the frozen pond located near the corner of MacArthur Avenue and Main Street on Sayre & Fisher property. The row houses on the left were erected on Jacobsen Street for employees. The Sayre & Fisher mule barn can be seen at the right in the rear. St. Stanislaus parish acquired this property for their school and playgrounds.

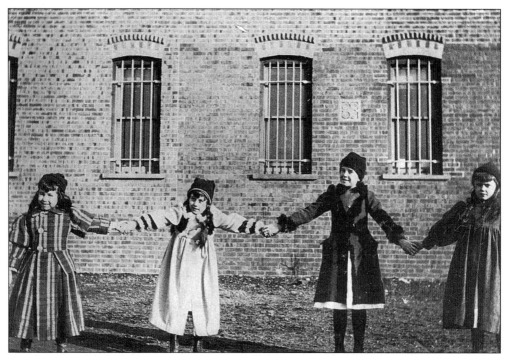

A group of young friends was photographed while at play c. 1890. Shown from left to right are Edwina Fisher, Olive Meeker, Mildred Fisher, and Lou Hendrickson. Edwina Fisher married Richard Krementz of Krementz & Company, a jewelry manufacturing firm in Newark.

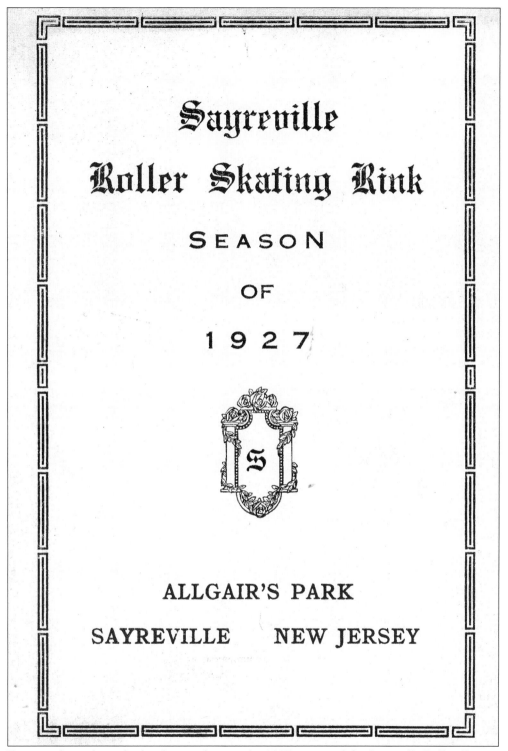

Sayreville
Roller Skating Rink

SEASON

OF

1927

ALLGAIR'S PARK

SAYREVILLE NEW JERSEY

You can almost hear the laughter and joy at the 1927 season of the Sayreville Roller Skating Rink at Allgair's Park.

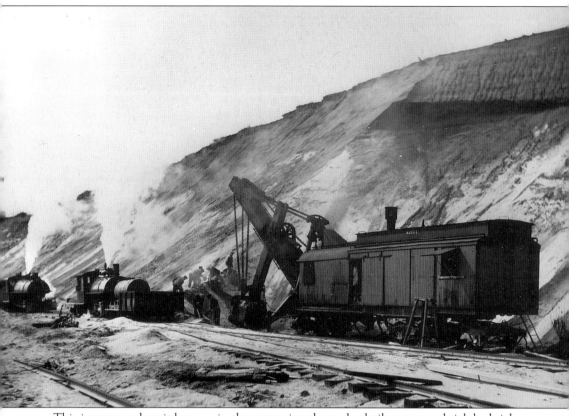

This journey ends as it began—in the open pits whose clay built our town brick by brick.